The
HISTORY
of the
SNOWMAN

The HISTRY *of the* SNWMAN

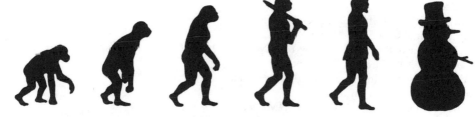

FROM *the* ICE AGE *to* *the* FLEA MARKET

SSE

SIMON SPOTLIGHT ENTERTAINMENT

NEW YORK LONDON TORONTO SYDNEY

S|S|E

SIMON SPOTLIGHT ENTERTAINMENT
An imprint of Simon & Schuster
1230 Avenue of the Americas, New York, New York 10020
SIMON SPOTLIGHT ENTERTAINMENT
and related logo are registered trademarks of Simon & Schuster, Inc.
Designed by Jane Archer
Manufactured in the United States of America
First Edition 10 9 8 7 6 5 4 3 2 1
Library of Congress Cataloging-in-Publication Data:
Eckstein, Bob.
The history of the snowman : from the ice age to the flea market /
by Bob Eckstein.
p. cm.
Includes bibliographical references and index.
ISBN-13: 978-1-4169-4066-1 (alk. paper)
ISBN-10: 1-4169-4066-9 (alk. paper)
1. Snowmen. 2. Snow sculpture. I. Title.
NK6030.E25 2007
736'.94—dc22
2007024820

To my wife, Tammy—
the perfect snow-woman

CNTENTS

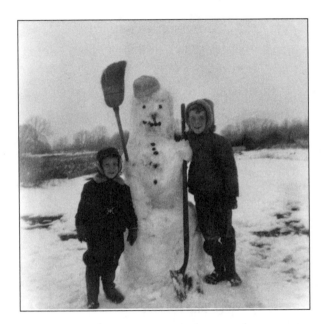

The SEARCH *for the* FIRST SNOWMAN

O nce upon a time there was a snowman. I am referring to the very first one.

Who *did* make that first snowman? Who first came up with the idea of placing one snowball atop another and then stuck a carrot in the top sphere?

As good a question as any in my book, this has been my personal quest for the past few years, my own Holy Grail: tracing the footsteps back to the very first snowman. It soon became clear to me that finding the origins of the first snow sculpture would be difficult at best. What evidence could be left? Random pieces of coal that were once the buttons to an ancient snowman's coat? Moreover, artists do not sign their snowmen. One might as well ask who sang the first song or told the first joke.

Despite the odds, my search began. I sought out museums with the earliest prints, examining their catalogs, my eyes racing across thousands of snowscapes hoping to spot anything that resembled a snowman: white blobs of snow topped off with a hat somewhere in the distance, a painting with a pheasant rolling a large snowball (possibly a torso) onto a pull cart, or an engraving of children playing

out in the snow. One group is suspiciously huddled around something unidentifiable, something white and pear-shaped—close calls but no cigar.

I went halfway around the world, speaking to historians and scouring their libraries high and low for clues. I met with experts in religion, the arts, professors of medieval customs, heads of Asian studies. I combed turn-of-the-century publications, historic journals, and eBay. I looked everywhere.

Sometimes the snowman found me, popping up at the most unexpected places. One hot, humid day, I found an important snowman at a rare book show. I was only there because my wife was selling her artist's books and she had a free pass for me, but I was intrigued when I learned that she was sharing a booth with a Sherlock Holmes collector. His centerpiece was a rare one-of-a-kind letter from the writer Arthur Conan Doyle in which Doyle first mentions a character named Holmes. *Ah, Holmes!* Who better for a great unsolved mystery? But, alas, the $150,000 letter contained no insights into snowmen. Leaving my wife and her boothmate to their vending, I ventured off to mingle in the world of antiquity.

I didn't have to go very far. The neighboring booth had very old travelogues the size of Bibles on display. The group of dealers outnumbered the handful of books, so I knew they were valuable. Pretending I could afford any of the items, I started to talk turkey with one of the dealers about a particular book that was opened to an illustration of explorers greeting Indians in the New World.

"$500,000? That's a good deal," I replied without a clue. The half-million would get me *Petits Voyages*, a landmark atlas, which included prints by the famous engravers the De Bry brothers. Back at home, with the use of a magnifying glass, I had found a snowman in a De Bry engraving in a book called *The Art & History of Books*. But here was the real deal, the original book—exciting because the only other place I knew I could find a copy of *Petits Voyages* was at the temporarily closed Morgan Library in New York City (whose curators later confirmed that there was indeed a tiny snowman in this ancient engraving, and were equally ecstatic). I had given up hope of ever seeing this book in person, but here it was, behind glass casement. While I pulled on white gloves I was given (to make sure I didn't soil anything in my

excitement), we all traded smiles, and I noticed that nobody had yet caught on that there wasn't a snowball's chance in hell of me writing a check for $500,000.

It only took me seconds to find the winter scene, easily the most bizarre and the only one with a completely barren landscape (*Petits Voyages* documented all the different voyages and explorations of the time and most of the drawings were of lush tropical places). The engraving of the winterscape illustrates the explorer Willem Barentz conversing with a group of Inuits during his last attempt to find the Far East Passage. In the center of the illustration is a sled pulled by two reindeer, and men hunting with bows and arrows. When I pointed out the snowman in the background, I was the dealer's new best friend—this newfound anecdote just increased the book's value and hiked up the asking price. The page would be bookmarked for prospective buyers.

Not everyone was as enthusiastic about my quest for the first snowman. A couple of years after the book show, I drove to Schenectady, New York, in pursuit of very real allegations that a snowman had guarded Fort Schenectady on the eve of one of the bloodiest incidents in early American history, the Massacre of 1690. A network of scholars who preserve the town's long history provided me with background information and arranged for me to meet the local historian. But the date would never happen. A "traditionalist" in many ways (she was writing her book on a typewriter), when I asked her over the phone about a snowman within the context of early American history, her particular field, our conversation ended. She would shed no light on the issue of the snowman; she felt I was making light of history.

But who's to say what is important in history? Lexicographer Dr. Samuel Johnson said, "All knowledge is of itself of some value. There is nothing so minute or inconsiderable that I would rather know it than not . . . A man would not submit to learn to hem a ruffle . . . but if a mere wish could attain it, he would rather wish to be able to hem a ruffle."

"Much of history is hemming ruffles," said historian Dixon Wector, in response. As for me, I have dwelt at length on the history of the snowman because it is time to give him his due—time to hem his ruffles. I may not know why historians

would use sewing as a metaphor, but one thing I'm sure of is that the snowman's history is as colorful and as vast as many other items to which we give credence.

The snowman's story will establish his place in history. History is indeed an elastic, inviting concept, which encompasses the most remote records left on earth to the next dusting of snowflakes. Pioneer historian Leopold von Ranke, in 1860, called history both "a science and an art." Although it may not appear that the snowman changed history or afforded us any obvious lesson, time and time again, this frozen Forrest Gump has appeared during key historical moments. Like Gump, the snowman appears alongside dignitaries and celebrities in snapshots of our world's history, whether he is welcoming soldiers marching through the Berlin Wall or acting as spokesman in the eruptive labor disputes of the Lyndon B. Johnson administration. This book is as much about the snowman as it is a fingerprint of our pop culture.

I expected (and even understand) my failure to connect with the perturbed historian, but she turned out to be an isolated case. Professors and experts almost always greeted my quest with surprised amusement and genuine intrigue, a welcome break from the standard inquiry. They were supportive yet cautionary of the subject's inherent problems—for starters, that the first snowman has long melted and left us no fossils. As global warming improves the conditions for finding the remains of ancient people by melting ice, revealing more remnants of man in the northern forests of Canada, Siberia, Iceland, and Greenland, it's conversely the foil for ancient snowmen that are melting, disappearing. Even if the first snowmen somehow managed to stay unmelted and remain among us, they, unlike our human ancestors, would look the same as the modern-day snowman or at least theoretically could. It would require some kind of carbon-water molecule-DNA-ice-ring testing to determine the ancient snowmen from the freshly packed ones.

Surely we share very few of our hundreds of day-to-day activities in common with our ancestors. But snow sculpture may be one of them. As Plato was known to say, humans have a common and simple need to imitate what they see, to create

art, and depict themselves. As I continued to question professors of ancient culture, academics posed a question of their own for me: Why? What started me on this wild goose chase? Did I have some special connection to snowmen as a child?

I don't ever remember making a snowman as a kid. Until junior high, I grew up in the projects of the South Bronx and didn't go outside much. My first art form was painting NHL uniforms on plastic soldiers I had bought by the bag for ninety-nine cents. Those army men would become my first "political statement" before I would later become a political cartoonist. While researching for this book, I learned that early forms of political "cartoon" traced as far back as the Miracle of 1511, an event where a town created snow scenes with local politician snowmen, editorializing the gripes of the day.

I no longer draw political cartoons. I am best suited as a snowman expert, if such qualifications exist. I am well versed in the pastimes and recreational habits of centuries past, as well as enjoy an unhealthy obsession for snow, the Arctic, and history minutiae (e.g., as a boy I inexplicably studied things like the Christmas party aboard the *Hansa*, a ship that explored the Arctic in 1870). About 130 years after that soirée on the *Hansa*, I married an obsessive collector who accumulated anything and everything. Chalkware, barware, Farberware, Fiestaware, Siesta ware, antique underwear, Corning Ware, Pyrex ware, stoneware, and any other rare ware. She hoards milk bottles and any cow items. Midwestern fish decoys from the 20s, old maps, school maps, school globes, snow globes, and now snowmen. My wife and I spend most of our free time going to and fro auctions, yard sales, and flea markets to feed our addiction for collecting things. Walking through the endless tables of knickknacks, I discovered that there is always one figure that outnumbers the rest. Why are there so many snowmen? Is it possible to pass a table at a flea market without spotting at least a dozen of them in every form possible? I couldn't understand why this rotund figure was showing up on everything. Why snowman candlestick holders and not, say, Harry Truman or Charo candlestick holders? As I walked through these abandoned drive-in-theaters-turned-flea markets, I became more interested in learning how a seemingly silly stack of snowballs could wind up

becoming a universal icon on everything from tacky sweaters to cheese ball platters. What was so interesting about Santa's second banana that he should become the face of every bric-a-brac? For this, I had no answer.

Did it matter? Could there be any substance or meaning behind this phenomenon? Was I laughing with it or at it? At first I thought it was a bizarre curiosity in tacky art that romanced me (not unlike the bad paint-by-number paintings I collect). But then I came across an old, beat-up photo of a snowman. The snowman himself was poorly executed and asymmetrical, as if a preschooler had supervised his construction. He was really just a pile of snow. Sticks provided arms and a sly smile that indicated a calm, if not complacent mood—although, I must admit it was amazing how the twig projected an expression that almost gave the packed snow a personality. This little stick could have been placed in any old way, but it seemed to be at the perfect angle, as if any other way would not have worked. On either side, children posed with their new friend. They were wet, and they were proud. For the first time, I'd found the beauty of the snowman—his appeal and his presence—as the most naked, simple portrait of our humanity.

After spending most of my life making a living through visual arts, I dropped those conventional methods to investigate this primitive form of art. Finally, I would be exploring the art form of snowman making and, for the first time, *I* was making snowmen. I was committed to finding out all I could about the snowman.

Picasso has never appeared in a breakfast commercial, but the snowman has. Muhammad Ali and Jack Nicklaus combined haven't graced as many magazine covers as the snowman. Who's had his face on more postage stamps? You'd be hard-pressed to find a celebrity who crosses international boundaries as universally as the snowman. The snowman, I realized, has become such a common icon that he has become invisible; we've taken him for granted as the King of Kitsch and, in doing so, obscured his place in our culture. No one is more beloved, more popular than the snowman, appeared in more movies, mentioned more often in literature, or landed more endorsements hocking everything from Cadillacs to laundry detergent to tuna casserole. Arguably—with the exception of religious figures—the snowman is the single most recognized icon in the world.

I was sold. My quest for the first snowman and his creator had begun.

Snowman's Index

Usage rank of *snowman* out of the 700,000 English words spoken or written : 44,427

Approximate number of books with *snowman* in the title : 500

Approximate number of those titles that are for adults : 15

Chances that they are about cocaine trafficking : 3 IN 15

Number of movies with *snowman* in the title : 22

Number of those in which the snowman is the killer : 6

Length, in minutes, of the 1896 silent movie *Snow Men* : 3

Years it appeared after the invention of the first silent movie : 1

Number of silent movies made about snowmen : 4

Number of them that survives today : 0

Number of snowmen made in Sapporo, Japan (breaking the world's record in 2003) : 12,379

Number of those snowmen that survives today : 0

Number of snowmen made in the village of Shiramine, Japan, during snowman week in 1993 : 2,000

Number of people who were living in the village of Shiramine : 1,200

Number of Americans, per 100 million, with the surname Snowman : 130

Number of those who live in Alaska : 0

Number of those who live in Florida : 21

Average number of snowflakes it takes to make a snowman : 10,000,000,000

Average number of calories burned, per hour, building a snowman : 238

Number of companies selling "only snow required" snowman-building "kits" : 4

Height, in feet, of "Mr. Huge," an inflatable snowman : 11

Height of "Angus King," the world's largest snowman : 11 STORIES

Weight, in pounds of snow, of Angus King : 9,000,000

Time, in weeks, it took Angus King to melt : 15

Number of automobile tires used to represent Angus's mouth : 6

Number of historical pieces of art on record at The Hague's Royal Library : 8,000,000

Number of those defined as "winterscapes" : 15,000

Number of snowmen found within that collection : 2

Estimated number of searches made per day on the Internet for *snowman* : 1,400

Chances that the snowman in question is "Frosty" : 1 IN 3

Approximately, the number of "snowman" items for sale on eBay on any given day : 37,000

Winning bid for a 3-inch German cotton snowman ornament on eBay : $315

The MODERN SNOWMAN

T he history of the snowman has been a mystery up until now, which is surprising since its evolution is as fascinating and preposterous as any, and mirrors our own ever-changing, often ridiculous pop culture. A snowman is a product of the times, and its true meaning is lost without an understanding of the people who made him. That said, to best understand the snowman's journey through time, the snowman's history has been divided into two parts, in reverse-chronological order. The first half examines the Modern Snowman, a label not bound by dates as much as intent and appearance. If you had to pick him out of a lineup, you could easily distinguish the Modern Snowman as the one wearing a hat and a stupid grin. The Renaissance Snowman, however, would probably actually *resemble* someone and would convey a message, sometimes political.

In modern times the appreciation of making snowmen has been woefully neglected. Its omission from art history is probably due in no small part to the fact that any and all great art made out of snow

has since melted. We may be 80 percent water, but the snowman is 80 percent air (snowflakes are 20 percent water) with no shelf life and worse, no tangible value, a real no-no in the art world.

The Modern Snowman came into his own approximately at the turn of the nineteenth century, around the invention of the postcard, when the image of the snowman became a cog of commerce, exploited to sell any number of products. It is therefore not surprising that over time he has become an increasingly generic icon. He's not political—he stays nonpartisan so he can hock the newest sedan on TV. Although not an atheist, he is nondenominational so he can provide broad appeal across the board to all. Like America, he's up to his neck in paperwork and litigation. A New Jersey federal court of appeals recently ruled that plastic snowmen counterbalanced the menorah, crèche with manger, and Kwanzaa symbols in question at a city hall holiday display. If Frosty was absent, the court declared, the entire display would have to be dismantled by force of federal law. The court reasoned that, in conjunction with Frosty, Santa, the menorah, and the manger were no longer religious symbols, but secular holiday decorations.

The desire to phase religion out of the holidays is an ongoing tug-of-war, in which the snowman gets caught in the middle. The Komsomol of Russia tried to do exactly that in the 1920s, when Christmas trees were topped with a red star and the snowman was the main symbol for "Komsomol" holidays. Friendly, innocent, and nonthreatening to society, the snowman was totally approachable (except to Lenin, who ended the movement). A child learns early that the snowman will not strike back even if he plows his toboggan through him or if he throws an icy snowball square at his face. It's all okay. The snowman's only kryptonite is the sun.

For children, making a snowman is the first and probably the last time they will create a life-size human figure. Whether it's a primal instinct or a learned skill, snowman making is always precipitated by joy—nobody makes a snowman against his will. Like Pavlov's dogs, kids run to the window as soon as snow starts falling. When the free art supplies start to blanket the yards, it can't be long before snow

people begin appearing on front lawns. Snowman making often follows a child's most awaited joyous announcement in her preadult life: that school is cancelled due to a debilitating storm. Snowmen were once happy people made by happy people in happy times.

Not so much now. Times are changing, kids are changing, and snowmen reflect that change. There are fewer happy people, fewer happy times. Snowmen today are more bulbous and out of shape, a reflection of our inactivity. Even on a linguistic level, physical activity has now become equated with work: "I'm going to spinning class to *work out.*" Not only are children less active, but snowmen stopped being cool to make, a development linked to Styrofoam snowmen.

The snowman's image came close to a reversal of fortune when rapster Young Jeezy made the snowman T-shirt the most sought-after piece of clothing in years. If anything could de-nerd the snowman persona, gangster rap would do the trick, or so you would think. Unfortunately no video of Young Jeezy creating a snowman was forthcoming; instead, the videos *Soul Survivor* and *My Hood* depicted him surviving in the hood and keeping it real. It's not even snowing in either video.

Worse, the use of the snowman on the T-shirts actually symbolizes coke dealers as part of a fad called *fashion crack*. Many shirts also imply cryptic anti-police messages on the back. Some schools decoded the shirts and have since banned them.

The Association of Education Publishers established an across-the-board ban on the word snow*man* from schoolbooks and any educational materials being that it is gender biased. The association demanded the word be replaced with snow*person*. Whatever you want to call it, snowperson–making itself was banned altogether when the Taliban swept

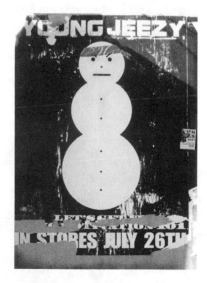

The snowman made popular again by rapsters.

to power in 1996 as fun itself was sent on holiday and the Taliban outlawed all nonreligious art and music, prohibiting children's activities such as kite flying, playing with dolls, and building snowpersons.

This is not the first time the reputation of the snowman has taken a hit. Consider that the word *snowman* means totally different things to totally different groups. It was once a racial slur, derogatory for white people. In Japan, the term *snowman* is a slur for lying politicians who deal us "snow jobs." Golf hackers hate the word *snowman* because it means an eight, a disastrous triple bogey at best, depending what par is. Psychologists say that seeing a snowman in your dreams suggests that you are emotionally cold or have perhaps behaved insensitively and coldheartedly.

Somehow through all of this, the snowman has only gotten bigger. He may have zero coolness quota but he's never been more popular. It's no coincidence that he reigns as the king of craft—so says every yard sale, flea market, and holiday high school craft show.

While the flea market might be a barometer of the popular trends of yesterday, it's really the end of the retail road, a retirement home for second-tier folk art, the equivalent of a Hall of Famer signing balls at the mall. At first glance, it's junk as far as the eye can see. This is where every item's retail value has hit rock bottom. The paradox is that this is the beginning of our search. These are the archaeological digging grounds for clues to the snowman's past, his fossils—whether in old movies, tchotchkes, antiques, or out-of-print books. This is where his history waits to be unearthed.

The journey begins . . . Photo: Nicholas Danilov, MosNews.com

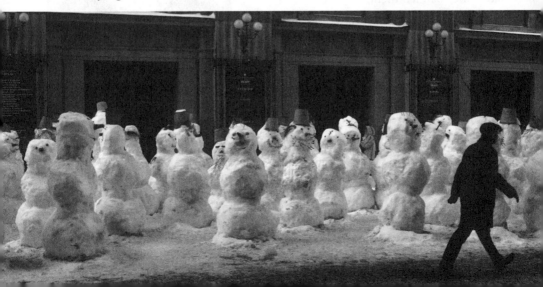

The AGE *of* EXPANSION:
THE TWENTY-FIRST CENTURY

snowman: A figure of a person made from packed snow, usually formed by piling large snowballs on top of each other.

—The American Heritage Dictionary of the English Language

The era we currently live in is The Age of Expansion, a time of grandeur when the snowman was never bigger. Our society's stance on size is that it still matters. From SUVs to plasma-screen TVs to McMansions to six-foot heroes, living large is being in charge. Putting deli meats aside, today we all want to make an entrance with class, and right now that means the largest diamond, the biggest pecs, the largest breasts, and the most headroom of any sedan on the market. This preoccupation carries over to Christmas decorations, which have gone to another level—it's not enough to keep up with the Joneses; it's necessary to squash them like a bug. So it's no surprise that our snowmen now need to be either a world-record holders or rubbernecking freaks of nature. Snowman contests, snowman festivals, marathons, lollapaloozas . . . like much else today, if it's not a spectacle, don't bother.

Today if you want a snowman for your lawn, you drive to the

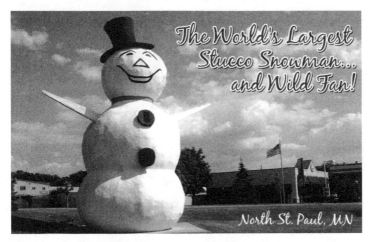

You'd be surprised how many snowmen are made out of stucco.
The Picturetown Collection

store. In an attempt to find another angle to cash in on the holidays, price clubs and better stores everywhere are well stocked with inflatable snowmen and snowman "kits." In this get-it-done-before-it-snows, fast-paced world of ours, there are different brands of snowman kits to choose from, all with prefabricated hats, buttons, pseudo coal and carrots conveniently packaged in a box so you or your kids don't have to get up and look for them yourself. Yes, everyone's snowman is going to look the same, but think of the time we're all saving. We're all too busy to go out and make snowmen, and, besides, what's the point of making one less than twelve feet tall? The buying of the largest possible snowman comes on the heels of

A transitional snowman bridging the era of the big snowman with the kitsch snowmen of the White Trash Years.
The Picturetown Collection

The White Trash Years (1975–2000) as a backlash against all those cutesy gift-shop snowmen we all got sick of up to here. But that's the cynical side of the story. The positive spin on this is that "Mr. Huge" and other inflatable rubber substitutes of the real McCoy finally give those who live in temperate regions the joy of having a snowman in their front yard. Think of the children. Think of the money.

Speaking of which, what about snowman making as sport and its gambling opportunities? It's all part of The Age of Expansion, when the snowman continues to blaze trails for tourism. Hundreds of snowman festivals and contests take place around the world every year and continue to grow. In Pennsylvania, there's an annual charity ice golf tournament on Lake Wallenpaupack after it freezes that includes a contest where golfers tee it up and aim for the vulnerable "Wally, the Snowman" down the fairway.

There are hundreds of similar events throughout the world. The biggest is the Ice Lantern Festival (Ice and Snow World) in Harbin. This bitterly cold, northern Chinese city, once known mainly for its expensive exotica cuisine of bear paws, deer nostrils, and white Siberian tiger testicles, is now recognized as the ice sculpture capital, attracting artists from around the world. Each year

"We built the biggest snowman ever heard of." 1882 engraving.

Picture Collection, the Branch Libraries, the New York Public Library, Astor, Lenox and Tilden Foundations

millions travel to the "Ice City," where the temperature stays below freezing nearly half the year. Held from the beginning of January to the end of February, thousands of enormous sculptures and buildings are exhibited and paraded on floats through the city. Although these snow shows date back to 1963, snow sculpture there dates back to the Qing dynasty about 350 years ago. During the Manchu days, "ice lanterns" were carved and then lit by placing candles in them.

A similar tradition is also enjoyed today throughout Japan, where snowmen

have candles placed in their stomachs during the many snowman festivals that take place every winter. Each year snowmen outnumber, at least for a while, the populations of northern Japanese towns. But are they big snowmen? Well, no, but rumor has it that the Japanese are eyeing that big prize, the world's largest snowman, an honor they enjoyed for almost four years thanks to a ninety-six-foot-tall snowman. Then, in February of 1999, Bethel, a town in Maine, placed itself on the map by breaking the coveted record, spending fourteen days piling snow skyward into what would become Angus, the King of the Mountain, named after the Maine governor, Angus King.

Extreme snowman making has come a long way since the day a bunch of frat boys from Dartmouth made the thirty-eight-foot-high Eleazer Wheelock, the headline act for the 1939 Winter Carnival. Today, making a huge snowman involves cranes, teamsters,

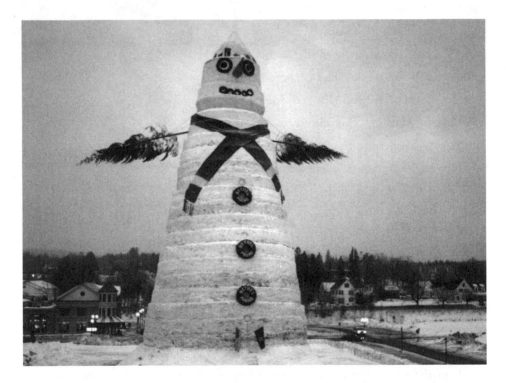

The World's Tallest Snowman, Angus King of the Mountain. *Bethel, Maine.*
Bethel Area Chamber of Commerce, www.bethelmaine.com

and insurance. Don't even think about making a snowball the size of an igloo without a working permit. In Bethel, their record-breaking snowman required sixty volunteers, ranging from kindergartners to senior citizens and the cooperation of the whole town. Angus's arms were made with two ten-foot evergreens. Volunteers created a mouth with six automobile tires and eyes with four-foot wreaths. The local elementary school made a six-foot carrot out of chicken wire and muslin and then painted it orange by having each student place his or her handprint on it. When finished, Angus reached 113 feet and entered

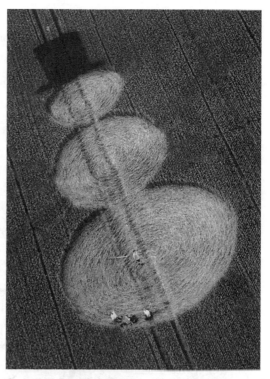

Snowman crop circle. The possible message from space could be, "Ours are bigger." © Bob Eckstein

the *The Guinness Book of Records*, attracting thousands of visitors and appearing on *Good Morning America*. Afterward, the town held a contest to guess when Angus would melt, and by mid-March, Angus had become "The Leaning Tower of Bethel."

Not every large snowman dies a quiet, slow death. Each year in Zurich, the Swiss celebrate *Sechseläuten* by using large amounts of explosives to blow up an innocent snowman. Always on the third Monday in April, bakers, butchers, blacksmiths, and other tradesmen parade on horses and throw bread and sausages to the crowds. In return for free meat, girls decorate the riders with garlands made of spring flowers. *Sechseläuten* (which means "six bells ringing") comes from the tradition that, at six o'clock, the guild members put down their tools and call it a day. Meanwhile, the *Boogg* is schlepped through town. The *Boogg* is a large, cotton-wool snowman with a corncob pipe, button nose, and two eyes made out

of coal—he looks the same every year because the same guy has been making the *Boogg* for over thirty-five years. Unfortunately for Mr. Boogg, he's filled with firecrackers and plopped onto a forty-foot pile of very flammable scrap wood. For him, things will only get worse. After the bells of the Church of St. Peter have chimed six times, representing the passing of winter, the townspeople light the pile and watch the carnage. It is believed the shorter the combustion, the hotter and longer the summer will be. When the head of the snowman explodes to smithereens, winter is considered officially over.

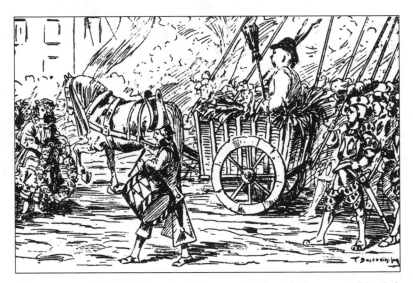

A snowman stuffed with dynamite being paraded through the streets of Ziruch for the explosive festival of Sechseläuten.

From *Sechseläuten Fest des Fruhlings, der Zunfte und der Jugend.* 1897 drawing courtesy of Orell Füssli Verlag Publishing.

CHAPTER TWO

The WHITE TRASH YEARS:
1975–2000

As a boy, Liberace made fantastic snow sculptures of deer and horses.
—from *Liberace: An American Boy*

No one ever went broke underestimating the taste of the American public.
—Mark Twain

Regrettably, The Age of Expansion was preceded by a dark period: The White Trash Years. "Snowman porn" websites littered the Internet. Shenanigans in slasher movies and general bad taste in the form of lowbrow home décor were par for the course during this embarrassing time. These were the carefree years of the Abominable Snowman running amuck. Archie-style comic books took a backseat to superheroes and story lines depicting evil snowmen who took on the likes of Batman, Wonder Woman, and Superman. There were disturbing reports in the press of anatomically correct snowmen. In Mary-Kate and Ashley Olsen's novella *It's Snow Problem* (2001), the twins make a trashy snow supermodel dressed in snow Capri pants and tank top.

But the snowman's fall from grace is part of the predictable and logical celebrity arc that becomes all the more clear as the

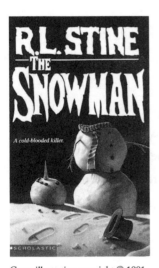

snowman's past is traced: (1) humble beginnings from the backwoods or backyard; (2) the big break with unforeseen fame and fortune; (3) reckless excess; (4) collapse; and finally, (5) a larger-than-life triumphant comeback. Humiliation is something most celebrities will suffer through. For Orson Welles, it was doing wine commercials; Burt Reynolds had his *Cannonball Run* series; William Shatner did Trekkie expos. Nevertheless, every celebrity ultimately enjoys a comeback and/or redemption. Even Nixon bounced back from Watergate by the time his presidential library opened. Every dog has his day. It's what we do as a society: We pick them up. It's how we forgive ourselves for whatever role we played in getting their lives into the gutter in the first place. And the snowman is starting to have his day in the sun now.

So we proceed without fear, assured that The White Trash Years was just a phase, a phase that, at its worst, culminated in the decision to cast the snowman in the movie role of a serial killer. (That said, the following material is adult in content, so if you are reading this to children or are squeamish, now would be as good a time as any to skip to the next chapter. Otherwise, welcome to the unsavory details of The White Trash Years, a combination of crass merchandising and inexcusable behavior.)

At some point in Tinseltown there was a meeting where a movie producer suggested that what the public really had a hankering for was a deranged knife-wielding snowman with a penchant for revenge. So began the snowman's new ill-advised direction in movies. Decapitation by sled, icicle

bullets, and strangulation by use of tangled Christmas lights? Not exactly the warm memories of a Yuletide of yore, but exactly what unprepared holiday frivollers got when they went to see *Jack Frost* (1996). Even the tagline of "He's Chillin' and Killin'" didn't prepare movie goers who watched in horror at what may be arguably the most tasteless scene in cinematic history: A noseless snowman rapes Shannon Elizabeth (of *American Pie*) in the shower. This film was followed by a sequel (for some reason), and *Jack Frost 2: Revenge of the Mutant Killer Snowman* was

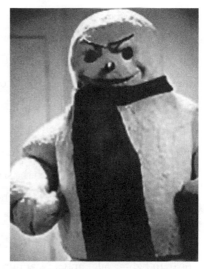

Psycho killer snowman from Jack Frost.

Jack Frost 1997

released in 2000 to equally cold reception. This time, the pitch was totally different for winter's bad boy: "He's Icin' and Slicin.'" It was set again in Snomonton, the fictional town looking for the frosty killer in a top hat. Feliz Navi*DEAD*.

Nineteen seventy-eight saw the release of a blaxploitation movie called *Death of a Snowman*. About the Asian mafia in South Africa, the fitting tagline read "Rougher and Tougher Than Anything You Have Seen Before," a fair assessment of its production values. Donald Sutherland appears in the movie but wisely managed to eliminate his name from the credits.

Other dangerous snowmen emerged in the medium of comic books. The evil Klaus Kristin, aka Snowman, aka the Snowman of Gotham, first appeared in *Batman* comics in 1981. An ice-powered criminal, his story is like so many others. Born the son of a Yeti (one of those Abominable Snowmen), he prefers existing in cold climates and traveling eight months of the year to follow blizzards. A nice idea, but impossible for him to hold down a steady job. Broke, he abuses his superpower—the ability to cause anybody to freeze solid—and begins robbing people. All well and good until Batman is tipped off to where Klaus Kristin's crib is and before you know it, he's on a plane to Tibet.

Another evil snowman is the story of the Blue Snowman. Like many of Wonder Woman's enemies, the Blue Snowman is sentenced to imprisonment on the Amazon penal colony program. There's something for everyone here in this tale of a transsexual killer snowman/woman with a heart of coal, who starts her own business firm (Villainy, Incorporated) and uses a telescopic snow ray to create petrifying blizzards as well as a defroster ray to reverse the effect.

Less sexually confusing but no less bizarre, is the *Snowman*, a long-running successful comic series in which the snowman is the lead. This out-of-control snowman is actually an Indian warrior ghost who goes around to even the score against the white man for the brutal murder of his wife. The adventures begin in the 1880s and include an episode during World War II when an American aviator must join forces with a German fighter pilot and a Nazi nurse against the agitated snowman.

Of course, many kids now consider comic books passé, but fear not, violent snowmen appear in many video games, too. From your joystick you can make snowmen (on the sedate The Sims Vacation) or take care of the Abominable Snowman in the zoo management strategy game called Zoo Tycoon. But most violent games with menacing snowmen involve bounty hunters and icy snowballs.

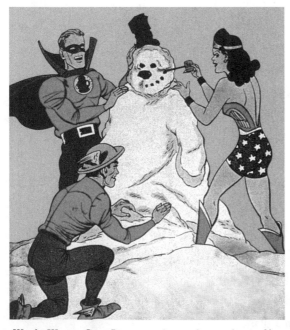

Wonder Woman, Green Lantern, and some other superhero making a snowman—without the use of their super powers! © DC Comics

While admittedly not exactly an exemplary citizen, the snowman's place in the social scheme of things has been a surprisingly heated issue. In Britain there was quite a brouhaha when, around the end of 2001, a female professor started snowman-bashing in the

press. The snowman is sexist and out of date, she declared, after a five-year study into the "cultural meanings of snowmen" and the snowman's gender discrimination. The art historian trashed snowvanist pigs in BBC radio interviews as "rotund relics of Bacchanalia . . . gluttonous and indulgent, [that] symbolized the grotesque with their portly appearance and carrot noses . . . They are white, they are male, they are fat [making them symbols of greed, and indeed capitalism], they are phallic . . . erected in front of the home, while the woman of the house is inside toiling . . ." Most of the academic's wrath focused on the Christmas snowman, "with its bulbous body, phallic [again] carrot-nose and blank, unindividualised eyes . . . Like Father Christmas, it is round and smiling, suggesting over-indulgence . . . the image of gastronomic indulgence." [The nutty fruitcake does have a high caloric intake.] The professor's biggest complaint was that snowmen are made outdoors—reinforcing the idea that the public space is a man's world. In her words, "Since the 19th century, there has been a segregation between the private space of the home, traditionally occupied by women, and the public space of business and outdoors, naturally occupied by men." Agreed.

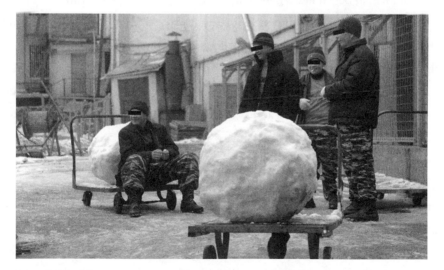

Rare glimpse of the snowman black market in which snowmen are kidnapped and sold like slabs of meat? No, further investigation actually proves that these young men are professional snowman-makers hired by The Russian Theatre as publicity for their winter season. Black bars were added by author for dramatic effect. Photo: Niholas Danilov, MosNews.com

Statistics will show almost all snowmen are made outdoors, where the snow tends to accumulate.

Professor Heatmiser did concede one positive attribute to snowmen: "About the only thing to be said in their favor is they have cut back on smoking; at any rate, you don't see them with pipes in their mouths as often as you used to."

Meanwhile, eBay was creating a more visible, far-reaching monster: the snowman as the King of Kitsch. Today, at any given moment on eBay, there are thousands of snowman items available for fervent collectors around the world. Fierce and unparalleled reckless bidding can erupt anytime over a knitted snowman kitchen appliance cozy or a rug-hooked toilet seat cover. Before the snowman motif was used for every craft you can imagine, he was the essence of folk art. A chance at self-expression, a creature of whim and climatic circumstance—whenever winter dropped a truckload of art materials in the form of snow right outside everyone's front door, it was an opportunity for the artist in all of us to come out. For some, it may be the only time of the year they allow themselves to create art—art that couldn't be more public yet rarely judged or criticized.

The snowman began like baseball or apple pie: a slice of American life, a form of folk art, the art of the common man. But today, folk art is art the common man cannot afford. Hotly pursued by collectors, the only folk art not expensive is schlock. Its price either skyrockets or it becomes kitsch, a staple of the craft community. From there, it has only one way to go—the natural snowman food chain, a retail purgatory of eBay and flea markets, eventually reappearing in yard sales at drastically reduced prices.

When did the snowman jump on the kitsch bandwagon? First, what is the kitsch bandwagon? The shorthand version: a series of pop culture events collided in the twentieth century. This includes the death of Elvis, coupled with the cancellation of *H.R. Pufnstuf* and *The Banana Splits* in the early 70s, triggering hanging prints of crying, doe-eyed children in American living rooms. Kitsch was in full swing by the 1977 fall season with trailblazers like *The Love Boat* and *The Brady Bunch Hour*. Barry Manilow dominated the charts with hits like "Mandy," "I Write the Songs," "Copacabana (At the Copa)," and "Looks Like We Made It." By this time

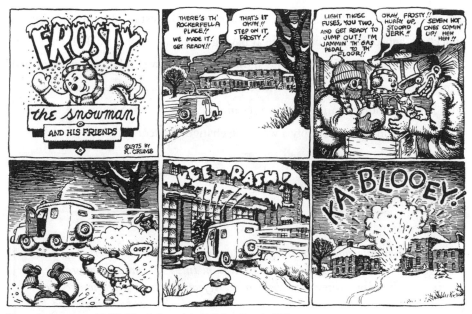

"Frosty the Snowman with His Friends," copyright © Robert Crumb, 1975

everyone had heard the saccharine tune "Frosty the Snowman" about eight billion times. The snowman was suffering from overexposure, and his brand name had lost its value. He'd made the wrong turn at the folk art fork in the road—next stop, Kitschville.

The snowman was a natural, fueled by the increasing popularity of snow domes, and Christmas specials by masters of the kitsch genre—icons like Andy Williams, Perry Como, and the King Family. As Wayne Hemingway says in his book *20th Century Icons*, "Holidays and kitsch go together like Donnie and Marie Osmond." It would take some time, but a dozen or so years later, the snowman would find himself in every yard sale next to Beanie Babies and Abdomenizers, unofficially but unquestionably crowned the King of Kitsch.

But The White Trash Years as a whole was *officially* ushered in by a different event in the mid-70s. During the troubled 60s, cartoonist Robert Crumb created the "Keep on Truckin'" mantra, the ever-popular hippie Mr. Natural, and sexually deviated cartoon characters that captured the sexual revolution. Crumb followed this in 1975 by drawing a cartoon of a terrorist snowman—Frosty driving a van full of explosives into the Rockefeller estate—obviously predicated by the

era that had just ended in disenchantment with the establishment and by our collective (subconscious) annoyance at having that Frosty song stuck in our heads. Before *Frosty, the Psycho Killer*, the snowman's image was relatively untarnished, symbolizing good old-fashioned wholesome Americana, a squeaky clean character who had accumulated an impressive résumé in Hollywood. Seeing the snowman in any edgy context was simply a welcome change of pace.

An unfortunate sidebar to the generally congenial snowman persona is the legend of the Yeti, the Abominable Snowman. In 1953, Indian mountaineers in the Himalayas discovered their own Bigfoot, drawing attention to their frozen foothills. Over seven feet tall, hairy, and apelike, he was spotted by Tibetan government officials.

Tibetans sincerely believe that Snowmen live on the slopes of Migo or "Snowman Mountain," and the legend of Yeti has a long history. One drawing from 1740 illustrates the story of a Yeti killing thirty villagers. An eighth-century scholar writes of the snow monster as well. A pre-Buddhist book contains a recipe for a magic potion that calls for poisonous roots, bone marrow, and the blood of a Snowman. Instructions say the Snowman must be killed by arrow or sword. The Yeti's history began when priests made a shrine inside their monastery out of the large, dried-out scalp of a Yeti (which they called a migo). The priests claim that all migos carry a large rock as a weapon and live long lives, no doubt, having that handy rock with them. The Lepchas, aboriginal inhabitants of a neighboring region, worship the Yeti under the name Chu Mung, the "Glacier Spirit," the lord of all forest creatures. With only some footprints and a fuzzy photo to work from, the Lepchas needed a snazzy name if this myth was ever going to take hold. Since "Migo, the Annoying Large Thing" doesn't sound scary nor does it have that pizzazz the Snowman moniker brings, they went with "the Abominable Snowman." Consequently, the smart marketing ploy has generated countless Abominable Snowman games and dolls, and the country of Bhutan has even issued a set of Yeti stamps.

Recently, a large brown bear has been found up on Snowman Mountain, raising questions as to whether it was "the Brown Bear" all along.

The HOLLYWOOD YEARS:

THERE'S NO BUSINESS LIKE SNOW BUSINESS

There's no business like show business, but there are several businesses like accounting.

—David Letterman

The snowman is best known, obviously, as Frosty the Snowman, a role that forever changed the world's perception of the snowman. But the snowman has always been a fixture in Tinseltown, appearing in hundreds of flicks, from the birth of the silent movies to classics like *Citizen Kane* to holiday blockbusters like *Holiday Inn*. While he has hit high notes, as in Raymond Brigg's animated *The Snowman*—a classic overseas—and was nominated for an Oscar, too frequently his Hollywood résumé is uneven, filled with questionable casting and bad scripts.

Exhibit A. In a curious career move, Michael Keaton played a reincarnated snowman in the painful *Jack Frost* (1998). The premise for this movie is repugnant on every level. Little Charlie, who lost his

dad exactly one year prior to the Christmas Day in the film, plays his father's magic harmonica, and his pop comes back to life as a snowman in the front yard. This is followed by the old snowman-comes-to-life-from-a-magic-hat/harmonica/or-whatnot-then-plays-with-the-children routine. The widowed mom soon learns of this development herself in an even more disturbing way: She gets a phone call from the snowman (raising both plot and logistical questions). In one of the movie's many poignant exchanges between the two leads, Jack Frost (the dad), says: "You da man!" Charlie: "No, YOU da man!" Jack Frost: "No, I da *snowman!*" Film critic Roger Ebert said in his book *I Hated, Hated, Hated This Movie*, "Never have I disliked a movie character more."

Two years earlier it was *Santa vs. the Snowman* (2002), a 3-D film intended for IMAX screens, in which Frosty tries to steal Christmas using igloos mounted on stilts à la *Star Wars*'s Imperial walkers. Again, it doesn't take a rocket scientist to see that the snowman was getting the short end of the stick in that battle. As with every other script, the story ends with him melting, or worse. It's no wonder the snowman began to explore the slasher flick genre in movies like *The Worst Horror Movie Ever Made* (2005). He had to vent. Frosty had had enough.

There had already been four (!) sequels to Frosty's initial TV debut in 1969, all with impressive stars. As recent as 2005, *The Legend of Frosty the Snowman* starred the voices of Burt Reynolds and the guys from *SpongeBob SquarePants*. Before that was the 1992 *Frosty Returns*, with Jonathan Winters and John Goodman, also bringing to the fold the lead singer of DEVO, Mark Mothersbaugh, to create more songs. That same year Frosty also starred in *The Spirit of Christmas*, a cartoon short originally called *Jesus vs. Frosty* made by the creators of *South Park*, Trey Parker and Matt Stone. In 1979, *Rudolph and Frosty's Christmas in July* starred Mickey Rooney, Ethel Merman, Red Buttons, and Shelley Winters. Before that was the second Frosty special since the original, 1976's *Frosty's Winter Wonderland*, starring Shelley Winters, Dennis Day, and Andy Griffith (playing himself!).

Frosty didn't change television, but he permanently transformed the image of the snowman into the homogenized figure we see now in potpourri-drenched gift-shops. It was Frosty that would become the most famous snowman in history,

Frosty was based on initial drawings made by *Mad* magazine cartoonist Paul Coker, Jr. who is still asked by children to draw Frosty, which he says, "luckily is just three circles."
Original art created for book in 2006 courtesy of the artist Paul Coker, Jr.

undoing five years of groundwork laid by snowman look-alike Burl Ives and his masterful performance as the highbrow snowman in *Rudolph, the Red-Nosed Reindeer*. Ives really took the role by the snowballs and made it his own, classing up the snowman's persona through star power, fancy clothes, and bling-bling. He's the standard by which other snowman narrators are now measured. In *It's a Very Merry Muppet Christmas Movie*, the snowman-narrator Mel Brooks is chided as a "Burt Ives wannabe." *Rudolph* was made in 1964, when things were looking good for the snowman. The next year, the short film *Help! My Snowman's Burning Down* was nominated for an Oscar. That performance obviously caught the eye of legendary film director Richard Lester who, the following year, cast the snowman as the spy in the Beatles' hit *Help!*

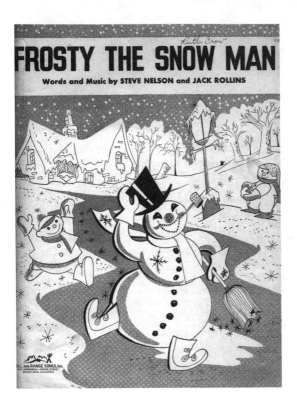

FROSTY THE SNOW MAN

Words and Music by STEVE NELSON and JACK ROLLINS

Frosty was the first snowman to get a lead role (in a talkie). In *Frosty the Snowman*, our protagonists set off on a chase to the North Pole, where nobody learns more about themselves. The 1969 project became a holiday standard and, no doubt, beloved by millions, secured the snowman's place amidst other nonreligious Yuletide icons like Santa, the Grinch, and Rudolph. Frosty was around twenty years before he would become FROSTY, the snowman on our television sets every Christmas season since 1969. Hollywood, forever trying to find a new holiday vehicle, tried to cash in on an old hit from 1950 about a magic snowman. Adding to the original song's story line was a little girl's struggle to elude a greedy magician who wants his discarded magic top hat back. We can only speculate what our perception of the snowman would be if Steve Nelson and Jack Rollins had not written their hit single. Frosty was born in 1949 after the two songwriters watched Gene Autry sell two million copies singing "Rudolph, the Red-Nosed Reindeer"— well before any of the holiday-special snowmen arrived on the screen. Nelson and Rollins immediately went to work on something equally bland. By the next year, they pitched a little ditty called "Frosty the Snowman" to Autry, who was just all too anxious to follow up his holiday success from Rudolph the year before (they brought plan B along as well: the Easter ballad "Here Comes Peter Cottontail"). There was obviously some magic in that Frosty song as it was a hit and made the

Top 40 chart the following year. Many recorded the song that year, including Jimmy Durante, with three making the charts: Nat King Cole, Guy Lombardo, and Gene Autry. Autry had two different versions, the best going to number seven in 1951. The song started a sensation, and the Frosty thing began to snowball. Frosty games, toys, and shirts hit the stores. Appearances in Thanksgiving Day and Christmas parades followed. "A Little Golden Book" of Frosty was published. In 1954, a three-minute animated short of Frosty aired on TV.

Frosty, from the tune, resembles a snowman in a children's book that preceded the famous song by five years. *Snowy the Traveling Snowman*, written by Ruth Burman in 1944, was about a magical singing snowman who also danced and played with children and, like Frosty, had coal for eyes, wore a high silk black hat, and smoked a pipe.

A passage from this rare Snowy book declared, "The snowman came bumpity-bump down the hill." The last line from "Frosty" the song concludes, "Thumpety-thump thump, over the hills of snow." Without question, thumpety-thump thump sounds like what someone—someone who really likes *bumpity-bump bump* but can't use that exact phrase—would use. The word *frosty* is also quite old, used by John Keats, and by Shakespeare in *As You Like It*. Snowy, like Frosty, makes a promise in the end to return again someday (but not stating whether in the form of a film, song, or bobble-head doll).

The Frosty song enticed many big-name artists to record a cover over time, including Bing Crosby, Perry Como, Ray "The Scarecrow" Bolger, Esquivel, Red Foley, Fats Domino, Ella Fitzgerald, Loretta Lynn, the Jackson Five, the Beach Boys, the Cocteau Twins, The Roches,

The original Frosty from 1954.

Courtesy of Ira Gallen of TVDAYS.com

The Ronettes, the Ventures, and Willie Nelson. "Frosty" even inspired other snowman songs. The Jaynetts recorded the promising "Snowman, Snowman Sweet Potato Nose." Petula Clark had a hit in 1952 with "Where Did My Snowman Go?"—a song Groucho Marx later sang on *The Ernie Kovacs Show*. The next year Gene Autry covered the song—perhaps the only snowman song Autry hasn't covered is Marilyn Manson's "Suicide Snowman." All this Frosty overexposure precipitated a sarcastic backlash song in 1953: "Frosty, the DeFrosted Snowman."

One of They Might Be Giants' snowman covers.

Reprinted with permission of They Might Be Giants/TMB Productions

There *was* life before Frosty. The snowman's first scene (and a pivotal one) in a major motion picture was in *Citizen Kane* (1941), regarded by many as the greatest film ever made. While Kane is constructing a snowman, his mom is inside, changing his fate, signing him away. The scene ends with talk about the snowman and Kane using his sled Rosebud to push away his new parental guardians. Some say this is the greatest scene Orson Welles ever filmed. Welles admitted that Kane's character was as much based on himself as it was on newspaper magnate William Randolph Hearst. The rotund director grew up in wintry Wisconsin, where he, no doubt, made snowmen—Welles had an obsession with childhood and was nostalgic about snow, using it as a device to convey innocence, like the snowballs of *Les Enfants Terribles* (1950) and the kiss in the snow in *The Magnificent Ambersons* (1942). At the end of *Citizen Kane*, a glass paperweight falls from Kane's hand at the moment he dies, and a close-up shows a snow-covered house flanked by a snowman inside the snow dome.

Hollywood used painted cornflakes for snow scenes. *Citizen Kane*'s snowman was made out of Styrofoam. It's so much easier just *drawing* a snowman. Cartoons

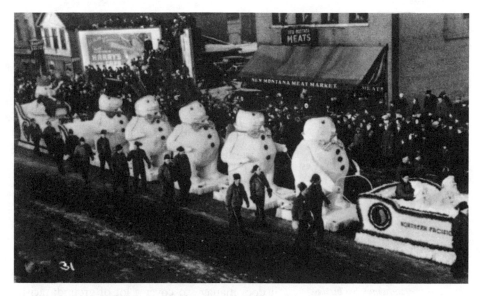

Every snowman has his day.

of snowmen have been produced in every corner of the world, including Albania, Bulgaria, Czech Republic, England, and Germany (all titled *The Snowman*). Walt Disney gave the snowman a gig in one of his first silent shorts in the *Alice* comedies made in the 1920s. During an Uncle Tom Cabin Show, Alice is bopped in the head and dreams of being in Snowland. There, Pete the Bear chases her across ice floes and then they make snowmen. Despite all this nonstop action, Mickey Mouse would eventually outshine Alice, and the *Alice* series would conclude.

Movies around the turn of the century always had the snowman coming to life. This included the Swedish cartoon *Kalle's Dream* (1916), which depicts the earliest animated snowman. Before that, only *live* snowmen appeared on film through the use of groundbreaking special effects. And *live* they were. One example was *The Snowman* (1912), a ten-minute black-and-white silent, in which a man dreams that a snowman

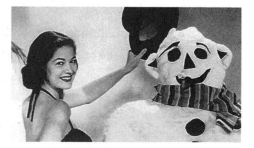

One of hundreds of snowmen cheesecake shots.

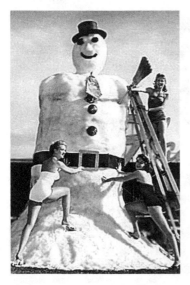

Again—every snowman has his day.

comes to life and chases him down. A more important endeavor from this era would be the earlier film *The Snowman* (1908), by Wallace McCutcheon, starring Robert Harron. The movie opens innocently enough, with children making a snowman. After dark, the snowman comes to life and frightens an African-American chicken thief into turning his live loot loose. The snowman then breaks into a schoolhouse and steals the stove. In the morning, an angry mob, led by the chicken stealer, finds a sleeping snowman and bludgeons him with a steel pipe. Only four minutes in length, it does manage to cover a lot of ground: racism, manslaughter, and grand larceny.

Stepping back even further in time to 1899, the film company Star Films, whose motto was "The Whole World Within Reach," released *La Statue de Neige* (aka *The Snow Man*). Anyone getting up for popcorn would have missed the whole movie. At about twenty-five seconds, it was no epic—but nevertheless an important advancement in cinematic history. Its director, Georges Méliès, was one of the world's pioneers of film, and today he is considered the early genius of special effects. Unfortunately, most of his movies are gone. *The Snow Man*, along with several huge crates containing the negatives of films from Méliès seventeen-year career, were destroyed under orders of Méliès himself in a moment of anger when his film business collapsed.

But Méliès's wasn't the first piece of celluloid with a snowman. That honor goes to *Snow Men* (1896), one of the first moving pictures ever and the earliest casting of a snowman. The historic film captures three minutes of street urchins creating a snowman. Not many have seen the movie (it is not available at Blockbuster), so movie reviews of the snowman's rookie performance are nonexistent.

Even this, however, was not the snowman's first taste of show biz. The snowman, predictably, began his career in vaudeville. Under the watchful production eyes of Professor Carl Marwig, his students at the Academy of Music in New York City put on a "new, brilliant programme" called the *Children's Carnival and Ball*. Cited in 1878 in *The New York Times* as "wonderful," the snowman's big scene comes in the fourth act after the grand march and procession followed by, of course, the Spanish national castanet dance. It is then that the Jee Queen, assisted by "her court of snow-men," is brought out in a sleigh drawn by polar bears. Before anyone can pose the question "Who will dance a comic snow polka?", spontaneous polka activity erupts bringing down the house. That's entertainment.

That humble beginning on Broadway opened the floodgates to hundreds of theatrical productions revolving around snowmen. The most successful of the time was Erich Korngold's ballet/pantomime *Der Schneemann* (*The Snowman*) at the Vienna Court Opera in 1910. Written at the age of eleven, Korngold's first composition caused a sensation and would start his emergence as a renowned musical figure of the twentieth century.

Today, about one hundred years later, the snowman may occasionally make a film cameo (*Elf*, *Groundhog Day*, *Gremlins*, *Polar Express*), but his days of top billing are looking bleak. No doubt, bad scripts and stereotyping have led to an icy track record at the box office. Will Hollywood ever roll the dice on Frosty as a leading man again? It seems likely. The snowman still enjoys enormous popularity in advertising, a field that will continue to open doors for him. With indispensable name recognition, he won't be kept out in the cold for long.

Snowmen also find it difficult to film with live animals.

Originally published in *Child Life* in 1935. Photograph by Harry Whittier Frees.

Courtesy of Rick Goldschmidt Archives (rankinbass.com)

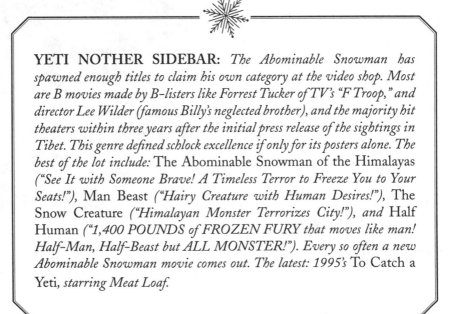

YETI NOTHER SIDEBAR: *The Abominable Snowman has spawned enough titles to claim his own category at the video shop. Most are B movies made by B-listers like Forrest Tucker of TV's "F Troop," and director Lee Wilder (famous Billy's neglected brother), and the majority hit theaters within three years after the initial press release of the sightings in Tibet. This genre defined schlock excellence if only for its posters alone. The best of the lot include:* The Abominable Snowman of the Himalayas *("See It with Someone Brave! A Timeless Terror to Freeze You to Your Seats!"),* Man Beast *("Hairy Creature with Human Desires!"),* The Snow Creature *("Himalayan Monster Terrorizes City!"), and* Half Human *("1,400 POUNDS of FROZEN FURY that moves like man! Half-Man, Half-Beast but ALL MONSTER!"). Every so often a new Abominable Snowman movie comes out. The latest: 1995's* To Catch a Yeti, *starring Meat Loaf.*

The GOLDEN AGE *of* ADVERTISING SINCE *the* EARLY TWENTIETH CENTURY:

SNOW SELLS

He could sell snow to an Eskimo.

—Overheard in a real estate office

I t may at first just seem like a bloated exaggeration, just shtick, but the fact is that throughout the twentieth century the snowman enjoyed as much commercial airtime as anyone. This was not a reflection of the snowman's success in Hollywood as much as his success on Madison Avenue, appearing nonstop in television commercials after the boob tube came on the scene. He hocked everything and anything from soup to soap, from insurance to asbestos. The ultimate pitchman, the snowman was without peer, perched on top of advertisers' A list; he sold oatmeal, tractors, Cadillacs, children's clothes and booties—even his own flesh and blood: canned ice. There is nothing he would not sell for a buck.

Ad agencies find the snowman easy to work with and easy to tie in to any subject. First there's the snow factor. Any cold weather product either meant to defrost or freeze is a likely candidate. Ice

crushers, antifreeze, snow shovels, insulation for the home, winter shoes—all endorsed by snowmen. Then there is the holiday connection. You think holidays, you think Santa and snow. But, unlike Santa, the snowman has conveniently distanced himself from any particular denomination, broadening his demographics and making him a more sensible choice of salesman. A holiday giveaway snowman snow scraper won't offend anyone. Marketing departments have reasoned that since snowmen are made of snow, anything white and powdery was game. This meant manufacturers of salt (Snow White), flour (Snoflour), farina (Cream of Wheat), sugar, soap flakes (Ivory soap), ice cone machines (Hasbro), toothpaste (Colgate), refrigerators (Copeland), antacid (Phillips' Milk of Magnesia), and even cocaine (in the form of T-shirts) . . . all lined up for the snowman's services.

That's only part of the picture. With the snowman, you're starting with a clean slate, literally and figuratively, ready to emote whatever's needed for the job. A PR's

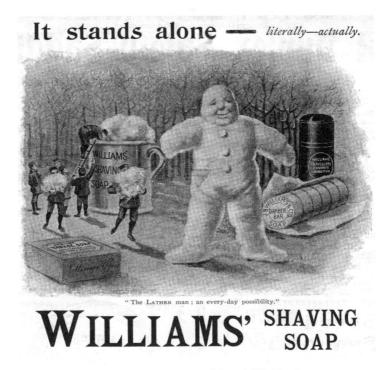

The first published snowman advertisement—Harper's Weekly, 1896.

The Picturetown Collection

dream—a totally pliable public image to suit any account. Want your clothes clean and white, like a snowman? Selling cigarettes? The snowman exudes "cool, fresh air," even when he's up to two packs a day. Personal hygiene was also crucial, and the snowman sold perfume (Lanvin Parfums, France, 1955) and dandruff lotion. According to the

scare tactic taglines of Jeris Antiseptic Hair Tonic, dandruff costs many a man that special lady or important job raise—"The Snow Man rides alone," or "The Snow Man behind the eight ball at work." In another big account, Colgate's 1953 campaign argued to women that "if it's kissin' you're missin', better look to your breath" because it's "sno wonder you're getting the cold shoulder from men. But even a snowman's better than no man."). Even weight loss turned out to be the snowman's niche—selling girdles for the Jantzen lingerie company in the 1950s.

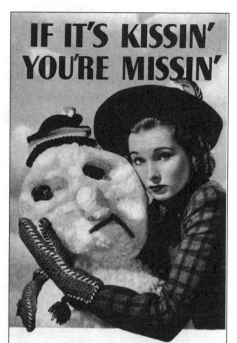

"The snowman never melts in snapshots," Kodak cameras promised, claiming to be the family camera of choice. How should a mother and daughter broach the uncomfortable subject of tampon (Kotex, 1949) use? Throw a snowman in the mix to break the ice—a whole lot better than having Dad there. The snowman provides a feeling of family closeness. Someone had to build him, which

Originally appeared in Time, *1957.*

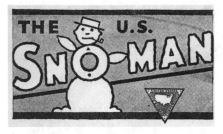

Package delivery service.

means collaboration, bonding—how could that not lead to girl talk? Frequently the snowman is there just to symbolize goodwill, honesty, purity. Naked but not sexual. With nothing up his sleeve. You'd buy a car from him.

It's no wonder the snowman is the logo for dozens of establishments for a wide array of industries, companies like Frost King (of home improvement products), Snow's milk, and the U.S. Sno-Man delivery service. He has that certain savoir faire that translates across international lines, making him a logical choice whether selling sardines (Amieux Frères) in France to beef bouillon (Bovril) in the States. Friendly, fat, and identifiable is an advertising formula used by many copycats like the Michelin Man, the Pillsbury Doughboy, the Maytag Repairman, and even Mr. Bubble. All a poor man's snowman. It was one of

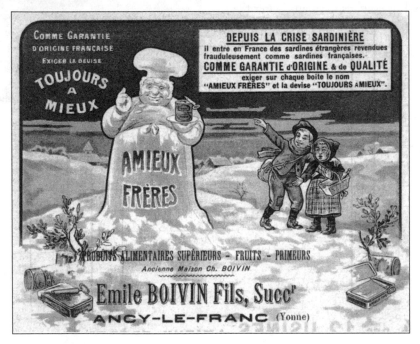

French sardine ad. (1930s)

the big lessons for big business: If the product could be tied in to an everyday figure, all the better. Companies like Quaker Oats made their trademark friendlier, more approachable, switching from an uptight, humorless salesman to the plump, smiling fellow with the silly hat, inadvertently opening the floodgates for another similar character: the snowman.

That's what the good people at Snowdrift Shortening were thinking in 1925 when they used a chubby snowman made of fat as their company image. This was years before big business learned that fat sells . . . and not for just selling fat. That same year, Snoboy fruit hired him as their logo to push their produce and started the longest run for a snowman as a logo, still appearing on their crates today. It was six years earlier that Beech-Nut ginger ale gave him his first big break as a walking snowman, hoisting a tall, icy glass of their finest. This marked the first time the snowman was made into a corporate logo; even more astonishing, the snowman's appearance came at a time when the concept of logos themselves was still a pretty outside-the-box idea.

Adorable icons . . . the bastard snowmen of advertising.

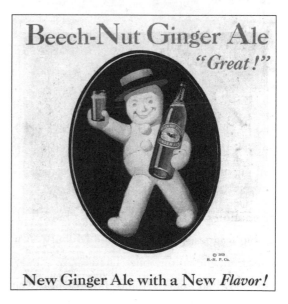

The snowman has arrived as a viable pitchman. (1919)

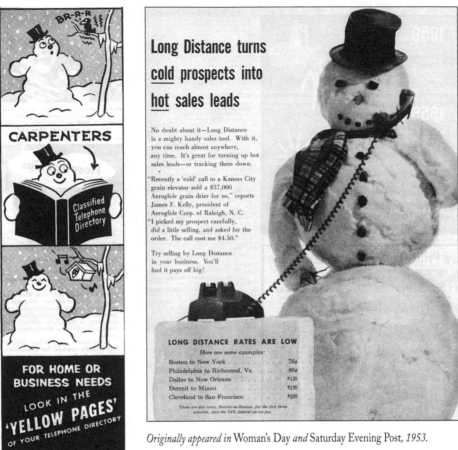

Originally appeared in Woman's Day *and* Saturday Evening Post, *1953.*

Before the snowman became a logo, he appeared simply as a pitchman, published regularly in magazines, sometimes holding up a product, sometimes just smiling at the camera. Just when it seemed like the whole world was moving to America and creating new consumer markets, savvy merchandisers increased their promotion and started spending big bucks. The snowman's first taste of the print ad big leagues was a gig for the Milburn Wagon Company, makers of that new sensation, the automobile. The year was 1917. The company's selling point was that they had manufactured the only lightweight electric car—and at the lowest price, $1,685. Advertisers had learned to exploit the snowman as a means to appeal to "everyman."

The print copy for an ad for Velvet Tobacco (1917) was textbook Merchandising 101: "Yo' face is shore familiar, like a man I uster know—I declar' now, Mr. Snow Man." Familiarity breeds trust. The year before, the snowman sipped from a mug of hot cocoa for Fry's Chocolates & Pure Breakfast Cocoa, "the children's favourites." The boy in the illustration pouring the cocoa for the snowman promises, "This'll keep you warm!" In *McClure's* magazine, in January of 1899, the snowman posed in thermal, "Full Fashioned Underwear" by Norfolk

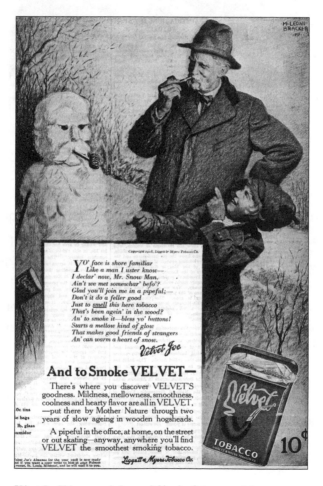

Velvet Joe Tobacco made "…good friends of strangers. An' can warm a heart of snow." Plus equally dangerous to humans and snowmen alike. Originally appeared in The Literary Digest, *1918.*

Illustration by M. Leone Bracker, 1917.

Originally appeared in The American Girl, *1952.*

and New Brunswick Hosiery Co. The ad was by no means racy; on the contrary, it was one of the only times the snowman is wearing clothes in a print ad.

Whether wearing thermal clothes, smoking tobacco, or drinking piping hot beverages, the occupational hazard of keeping warm did not deter this willing, jolly

The farmer whose estate just melted away...

Ad for New York Life Insurance Company originally appearing in Successful Farming, *1957.*

model. Just another example of the snowman taking one for the team.

How the snowman reached marketing super stardom is not a matter of rocket science. There are no royalties to pay when using a snowman image—his likeness has been in the public domain since day one. When that eleventh hour comes and there's nothing left in the budget, it's time to wheel in the guy whose public approval marks will always exceed his human counterparts,

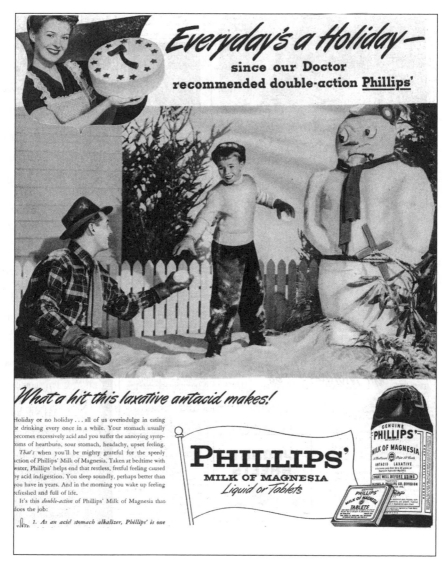

*Does your snowman have gas? Look how proud Mom is of her cake…it has an ax on top.
Originally appeared in* Life, *ca. 1950.*

works for free, doesn't mouth off, and never has a run-in with the tabloids.

The biggest niche in snowman retail is, however, the artificial snowman industry.
Plastic, Styrofoam, glass, wood, wool, silk, ceramic, Lenox, wax, rubber, golf balls,
cheese balls, white chocolate, marshmallow, singing, dancing, lit up, blown up, hung

Axton-Fisher Tobacco Co. (1938)

up, strung out, and hot-glued. Holiday decorations, Christmas ornaments, oven-size snow domes, hats, business ties, jewelry, leaf bags, candles, party hats. . . . If it can be bar-coded, it can be turned into a snowman. And now those mass-produced snowmen are becoming more complicated with their ready-made body parts and hard-to-find designer scarves to discourage us from using our plain household items. Where are kids expected to buy top hats today? Is this retail's way to get us to doubt our ability to make snowmen from scratch and resort to price clubs instead?

Don't buy into it. The biggest reason the snowman is the darling of Madison Avenue is the human connection we all feel in some way toward him, whether large or minuscule. For some, it triggers thoughts of making snowmen with our parents in a happier time, maybe when we were all still speaking to one another. For others, it triggers just faint fuzzy memories of being young and playing in the snow. Snowmen have always been popular because they're fun—and *easy*—to make. Children are not out in the snow making Wedgwood. Snowman making is probably even a primal instinct, some innate skill. Whatever it is, it's still an easy three-step process. If their natural habitat weren't so close to the equator, even monkeys could do it. There's not a whole lot of thinking involved.

That was not always the case.

The DEAN MARTIN YEARS:
DRUNKEN DEBAUCHERY
AND OTHER MISGIVINGS

If you drink, don't drive. Don't even putt.

—Dean Martin

To alcohol! The cause of—and solution to—all of life's problems.

—Homer Simpson

The phenomenal success of the snowman as a pitchman was just explained in mumbo jumbo ad nauseam, but does the theory of *why* really hold water? The truth is, the snowman's ad accounts quadrupled around 1934. Funny how Prohibition ended in 1933. Did he or did he not represent almost all of the country's leading liquor companies, including Miller beer, Ballantine Ale, Rheingold Beer, Schlitz beer, Schenley, Oretel's Lager Beer, Chivas Regal Scotch, Fort Pitt Pale Ale, Mount Whitney Beer, and both Jack Daniel's and Four Roses whiskey? Was this not directly related to his reputation at the time as a fun drunk? Did the snowman in fact have a drinking problem? Well, didn't every celebrity back then? But what sent the snowman into a tailspin that would become his *lost weekend*, a period of drunken excess and questionable activity?

Homer Simpson's toast was prophetic indeed, as it was the snowman's saturation in the booze ad market that catapulted him to marketing kingpin status and enabled him to pull himself up by his bootstraps. He cleaned up his act, started wearing nicer scarves, and changed to a classier silk top hat to cash in on the advertising front. But before this transformation he was a pickled, skirt-chasing, under-the-table lush. Or, in other words, comic great W. C. Fields. Oddly enough, by the 30s and 40s, the two started to look a lot alike, primarily becoming more round. Both started wearing straw hats, parading crimson noses,

Where the trouble really started—the movies.

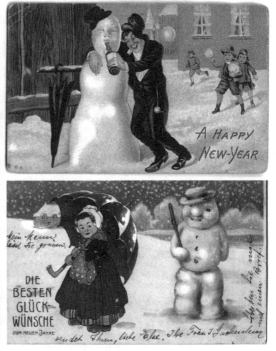

One of the "Hey, that snowman looks like W.C. Fields" cards.

and enjoying prolific silent movie careers based on their reputations as charming drunks. (One difference: W. C. Fields was known to hate the holidays. Ironically, he passed away on Christmas Day.) Who stole from whom? It's fair to say they were both partially indebted to each other.

Long after the snowman's bottle was empty, both his womanizing and his appetite for the ladies would continue, the latter throughout the Hollywood years. Numerous cheesecake publicity shoots, popping up mostly on calendars and matchbook covers, show bikini-clad starlets flirting with a deliriously happy snowman—and not just no-name tarts but celebrities like Dinah Shore, Esther Williams, and Shirley Temple. A disproportionate amount of holiday greeting cards from the 1900s to the 1930s show the snowman cavorting with women, drinking

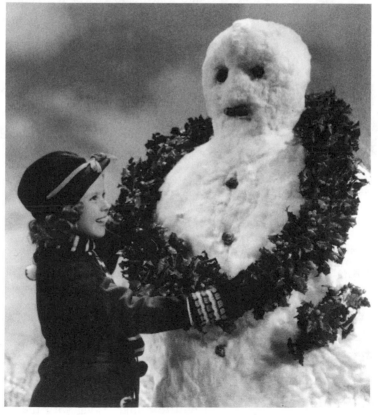

Shirley Temple

A bottle in one hand and pointed stick in the other.

Quite the ladies' man. French liquor ad.
Originally appeared in *L'Illustration*, January 1931.

The label from an old whiskey bottle dated 1890.

with minors, and loitering. Forever at the forefront of major changes in our country, he indeed mirrored America's drinking binge and fascination with smoking. While these depictions were, in a way, humanizing, seeing a tipsy snowman chasing a girl with a stick does not exactly sit well with us. Nonetheless, the popularity of these cards testifies that our society at that time embraced this plastered persona and found it very funny—the public could not get enough of the snowman getting intoxicated, stupefied, blotto, hammered.

So what precipitated that first drink? By 1908 there is already clear evidence of a problem. In Wallace McCutcheon's silent movie *The Snowman*, the chain-smoking snowman recklessly swigs whiskey until he is sloshed (and promptly flogged by the townspeople). Was this in the script? No one knows for sure exactly when the snowman began smoking a pipe and drinking hard liquor, but the two earliest public displays of this behavior on record are an 1898 illustration where he is toting two bottles of champagne in his arms, obviously on his way to some office party, and an 1890 label from a bottle of whiskey seen on the left.

Maybe the answer lies in the way he was treated. Could it be that the public drove him to drink? Along with the snowman-gone-wild postcards, there are a disturbing

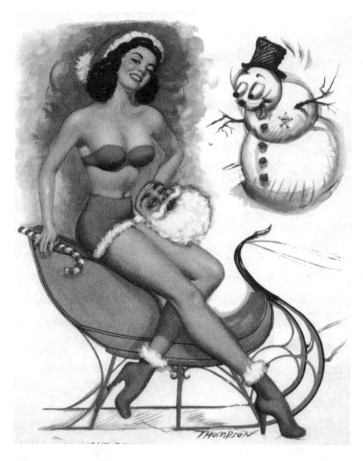

Calendar art, "'Twas the sight before Christmas."
Illustration by T.N. Thompson, 1956.

number of earlier cards illustrating the snowman being abused and humiliated by persons of all walks of life. A quick survey of early popular postcards show the snowman pelted with snowballs by a gang of wayward youths, plowed by speeding sledders or pig-driven toboggans, bludgeoned by two-by-fours, stomped on by tots, held up at gunpoint by little girls, stabbed with brooms, and posing in photo shoots with cats. In addition, the snowman appears in ads suffering from every embarrassing personal hygiene problem imaginable: dandruff, gas, hangovers, constipation, bad breath. . . . It was only a matter of time before the snowman became a spokesperson for Flomax and restless legs syndrome.

From The Baby Bears' Third Adventure
by Grace G. Drayton. (1914)
Illustration by G. G. Drayton

From polls taken at the turn of the century by *Journal of American Folk-Lore*, "making the snow-man a target" was one of a boy's favorite activities right up there with squat tag and stealing hot biscuits. Eighteen ninety's *Young Folk's Cyclopædia of Games and Sports* describes a variation of the nineteenth-century game Aunt Sally, in which children can score points by throwing snowballs at a snowman (instead of throwing sticks at a scarecrow named Aunt Sally). The low point, however, would have to be a holiday card showing Santa Claus in a convertible racing car about to run over a horrified and unprepared snowman. The snowman is screaming for dear life and looks ridiculous wearing a straw hat. It's no wonder the snowman turned to booze.

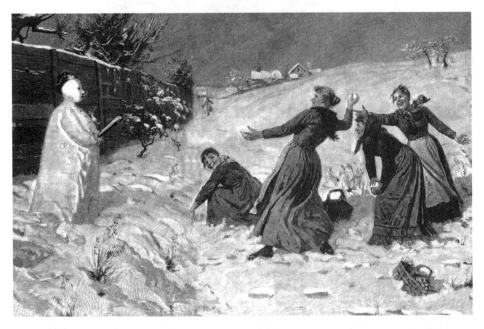

Pelting a snow cop who can't fight back in this rare late 19th century German engraving by Hans Dahl.
The Picturetown Collection

Typical of the cards from this era. Where's the adult supervision?
Illustration by Pauli Ebner

Happy New Year?

The snowman's psyche had taken quite a beating. We built him up only so we could, apparently, use him as a piñata.

To find clarity on this subject we, of course, turn to metered poetry. The following are excerpts from one of Canadian P. K. Page's favorite poems, "The Snowman," from the late twentieth century:

> *White double O, white nothing nothing . . . , this*
> *the child's first man on a white paper,*
> *his earliest and fistful image is*
> *Now three-dimensional. Abstract. Everyman.*
> *Of almost manna, he is still no man.*
> *No person, this so personal snowman.*

If you feel nothing from this, that's exactly the point: the feeling of nothingness. In 1921, at the depth of the snowman's jag, the poet Wallace Stevens attempted to capture the snowman's feeling of worthlessness

and anonymity in his famous poem "The Snow Man." Stevens wrote:

> *For the listener, who listens in the snow,*
> *And, nothing himself, beholds*
> *Nothing that is not there and the nothing that is.*

Stevens so perfectly captures the snowman's inner turmoil—his public perception was (and still is) the hapless sap waiting at the bus stop who gets splashed by the passing bus. Because of his anonymity, the snowman might be different to everyone, but most importantly, he is nobody to everybody. We can all relate to him. He's the last man picked on the team. He *is* everyman. And there is your reason for the snowman seeking solace in the bottle.

Another composition that offers a take on the inner workings of the snowman's mind is this one:

> *I made a snowman as perfect as can be,*
> *I thought I'd keep it as a friend, and let it sleep with me.*
> *I made it some pajamas,*
> *And a pillow for its head.*
> *Then last night he ran away,*
> *But first he wet the bed.*

While *this* poem, found on a needlepoint throw pillow sold at a garage sale, is not credited to a famous poet, it does something that other introspective poems do not accomplish: It rhymes.

The Dean Martin Years may have been the last time the snowman drowned his sorrows in highballs, but in the preceding era of Snowman Deconstructionism, the snowman lies down on the psychiatrist's couch. Long before the snowman became a textbook alcoholic, he was an icon in both high culture and art, inspiring both writers and artists alike who sought to flesh out his soul. Painters painted him. Songs were sung about him. Books were written about him. The snowman was the most important inanimate object in art.

SNOWMAN DECONSTRUCTIONISM:

LITERARY CIRCLES

Master the night nor serve the snowman's brain
That shapes each bushy item of the air
Into a polestar pointed on an icicle.
—Dylan Thomas, "Foster the Light"

I made a snowman and my brother knocked it down and I
knocked my brother down and then we had tea.
—Dylan Thomas, "A Child's Christmas in Wales"

No group loves the snowman more than flowery writers, who provide a bottomless well of metaphors for everything from death, to birth, to, of course, unrequited love. The snowman is melting, transient, and virgin white. All an excuse to psychoanalyze this blank slate to death, giving intellects carte blanche to suck the fun out of this simple pastime. Writers use snow as a symbol of, well, everything: (1) snow as memory, especially the recollection of childhood play; (2) life, including love, purity, and fragility; and (3) nothingness,

including isolation, silence, timelessness, and death. The crème de la crème is the aforementioned Wallace Stevens poem, "The Snow Man"—this fifteen-line stanza (actually just one long sentence) has become a staple in writing classes and is possibly the most overinterpreted piece of literature ever.

Stevens stated that his poem was about "the necessity of identifying oneself with reality in order to understand it and enjoy it." Stevens' snowman was the quintessential twentieth century American, preoccupied with his own misery and importance, yet superbly confident and self-aware. His mentor, Harvard philosopher George Santayana (no relation to Santa Claus), used snow as a metaphor for change in America when he wrote in 1920 (three years before Stevens' poem):

Any tremulous thought or playful experiment anywhere may be a first symptom of great changes, and may seem to precipitate the cataract in a new direction. Any snowflake in a boy's sky may become the centre for his boule de neige [snowball], his prodigious fortune; but the monster will melt as easily as it grew, and leaves nobody poorer for having existed. In America there is duty everywhere, but everywhere also there is light.

One thing is clear: Neither Mr. Santayana nor Mr. Stevens sounds like the type to go outside and make a snowman.

This was not the first time artists and great thinkers explored the snowman's psyche. A few years earlier, in London in 1916, there was a small, strange piece of theater called *The Snowman: A Metrical Play in One Act*. A snowman tries to initiate an affair with an unhappily married woman. The opening song (yes, it's a musical) goes: "He says his name is no man, no man, no man. And from nowhere and nowhere the land from which he came." (The snowman is a metaphor for the husband's nothing existence.) It's unlikely Wallace Stevens, or anyone else, was inspired by this play—it's probably just a coincidence. On the other hand, Stevens's one-sentence "The Snow Man" has inspired everything from a 1995 movie of the same name to Jasper Johns's renowned painting *Winter*.

Other brushes with high-brow art include Joan Miró's *Blue II* from the

triptych *Les trois bleus*, which, whomever you ask, looks like a melted snowman. When Miró's masterpiece was completed in 1961, the famous artist confided that his painting "was the culmination of everything I had tried to do up to then." Today, a handful of distinguished artists focus their works around the theme of the snowman. Visual artists have long grappled with perceived notions of what a snowman is and will continue to expand on that. The late polymath E. H. Gombrich did some serious expanding and expounding himself in his piece "Truth and the Stereotype: An Illusion Theory of Representation," from *The Philosophy of the Visual Arts*, a real bonanza of pontification. The best-selling art historian wrote:

The existentialist snowman. (The sticks translate to "snovym godom" in Russian which still means nothing which is maybe the point.)
The Picturetown Collection

> *We feel tempted to work the snow and balance the shape till we recognize a man . . . making will come before matching, creation before reference. As likely as not, we will give our snowman a proper name, call him 'Jimmie' or 'Jeeves' and will be sorry for him when he starts to slump and melt away.*

Even more impressive is the snowman's universal appeal in literary circles, appearing in many different genres of publishing, with enough titles to occupy a separate

Snowman version of Edvard Munch's The Scream.

section in a bookstore. Titles include *Snowman: A Novel* (Thomas York, 1976), *The Snowman: A Novel* (Charles Haldeman, 1965) *The Snowman's Children: A Novel* (Glen Hirshberg, 2003) and the real curveball, *Socrates, the Snowman* (Doris Gasser, 1980). Included in this stack would be literary heavyweights George Sand (*The Snowman*, 1858) and Joyce Kilmer (*Snowman in the Yard*, 1917) as well as modern-day classics like *To Kill a Mockingbird* (1960), in which the snowman is instrumental in Harper Lee's illustration of racism in Alabama. Poets Janet Frame (*Snowman Snowman*, 1963) and Sylvia Plath (*Snowman on the Moor*, 1957) have written prose on the circular figure. Nobel Laureate Wislawa Szymborska even wrote about the Abominable Snowman, "Calling Out to Yeti," that same year (1957). Recently, the snowman was one of the lead characters in Margaret Atwood's best seller, *Oryx and Crake* (2003).

Mr. Reversal of Fortunes, O. Henry, wrote his story with a twist no one could have predicted: A snowman doesn't die in the end; instead, O. Henry dies. The second half of the story was finished by short-story writer Harris Merton Lyon when O. Henry realized he was too ill to write anymore. Under the clouds of alcoholism, grave illness, and financial ruin, he told Lyon the details of his last story, "The Snowman," before he died in 1910.

FIG. 173.—Making "Frenchy."

The American Boy's Handy Book *(1882) included step-by-step instructions for building not just snowmen, but French snowmen, snow owls, and snow pigs.*

Drawing by Daniel Carter Beard

Predictably, children's books are most likely to feature snowmen. Illustrated children's books took off when the custom of Christmas gift giving to children began in 1825. The most popular present was the "gift book." Eventually, the snowman became one of the top dogs in the children's book genre, with hundreds of different titles in every age group to choose from—most ending the same way: in a melted puddle of water.

One groundbreaking book was *The*

American Boy's Handy Book (1882), a collection of articles by Daniel Carter Beard (cofounder of the Boy Scouts of America), and the first *For Dummies* book on how to conduct yourself on the schoolyard; regarding snowball warfare etiquette: "No icy snow-balls are allowed. No honorable boy uses them, and anyone caught in the ungentlemanly act of throwing such 'soakers' should be forever ruled out." In the book are step-by-step illustrations (by Beard, who was also an illustrator for Mark Twain) on building different snowmen, including a snow pig, and a Frenchman with a waxed mustache made of two icicles.

On New Year's Eve, 1860, one of the world's greatest storytellers, Hans Christian Andersen, wrote a story about a snowman and his friend, an old watchdog, who begs the snowman not to get involved with a wood-burning stove. Andersen called *Sneemanden (The Snowman)* a simple fairy tale, but critics disagree. One scholar, Benjamin Newman, feels the last line, "and no one thought about the snowman" is very telling, and elevates it from child's fairy tale to a metaphor of life (questioning the fate, existence, and another demonstration of Snowman Deconstructionism). In Newman's book, *Hamlet and the Snowman: Reflections on Vision and Meaning in Life and Literature,* Hamlet and the snowman are portrayed as heroic friends with common bonds and threads who both grope for something hidden, the real behind the surface:

> *The snowman frozen to the ground and when he knew where he was*
> *he began looking at life and the people around him at where they go and*
> *what they do and then he told us how he feels. In Shakespeare's Second Act,*
> *Hamlet addresses Rosencrantz & Guildenstern and the recent change in his*
> *state of mind which we know has been brought by the sudden death of his*
> *noble father and by his mother's marriage to his father's brother, Claudius,*
> *suspected murderer and usurper of the throne.*

However, similarities between Hamlet and Andersen's snowman stop there, the silk top hat notwithstanding. And, to clarify, there are no snowmen in *Hamlet* (although a crowned snowman does play Aumerle on the stage at Stratford-Upon-Avon in Shakespeare's *Richard II* in Act IV, scene i: "O that I were a mockery king of snow.").

Other scholars push the envelope even further. Is Anderson's *The Snowman* the first gay snowman? Of course all snowmen are gay; there's nothing gayer than snowmen. But was Andersen's snowman *gay* gay? *The Snowman* was a tale of misguided love, a snowman who falls head over heels for a stove that he mistakes for a woman. It's the usual boy-meets-stove, boy-falls-in-love-with-stove, stove-kills-boy love story. Experts argue that many of Andersen's fairy tales were expressions of his homosexuality and his protagonists the victims of unpopular sexual preference. *The Snowman* would be Andersen's best example of paying the price for falling in love with the "wrong" type. The stove represents the danger in this "wrong" relationship. It was written when—no coincidence—Andersen was pining for Harold Scharff. It's been said that Hans Christian Andersen did not even especially like children and wrote fairy tales to be well regarded in the public eye while using his imagination to disguise himself in his stories. *Strangers: Homosexual Love in the 19th Century*, by Graham Robb, called Andersen's body of work an "Aesop of 19th-century homosexuality." The two novels he wrote before his first collection, *Fairy Tales*, contained homoerotic scenes. But no snowmen.

Was *The Snowman* gay? Are we really even sure that Hans Christian Andersen was gay? First off, *The Snowman* was hot for what he thought was a woman, not a stove. There weren't any love scenes, per se, not even a kiss. Actually, the snowman's first kiss took place sixteen years earlier, when Andersen wrote *The Snow Queen*, about a northern femme fatale made of ice—a parody of and retort to Swedish singer Jenny Lind, the object of his affections, who wouldn't give him the time of day. The story of *The Snow Queen*, in a nutshell, is about man's lifelong quest for validation by women and the pain of unreciprocated love. All familiar ground for men. All very familiar ground for Andersen.

Stamp made by The Stanley Infant & Junior School celebrating their 50th anniversary and Hans Christian Andersen's 200th birthday in thanks for his possibly misinterpreted love of children.

Issued by the Falkland Islands

Needless to say, we know from the recent merciless exposing of Andersen's frank diary that he didn't "close the deal" with anyone besides himself, and an argument can be made that his stories were a reflection of rejection and frustration. He had so fabulously struck out with the ladies that it seems he simply expanded his dating pool to men to hedge his bets.

In any case, the snowman had better luck than Andersen and was on a roll after *The Snow Queen*. He would get another kiss in Nathaniel Hawthorne's *The Snow-Image: A Childish Miracle*, written in 1852, about a little girl who makes a "sister" out of snow that then comes to life after a kiss by the girl. The family invites the new member of the family into the living room, where they accidentally melt her in front of the fireplace. *The Snow-Image* was one of the earliest snowman stories in print. Mention of snowmen in fairy tales or children's books before *The Snow-Image* is just in passing. An example would be an anonymous illustration containing a snowman, in the Royal Museum of Art and History in Brussels, to a story by Charles Perrault from the late seventeenth century—the artwork

Dennis Oppenheim, Snowman Factory, *1996. Rolled aluminum, casters, rubber molds, cast fiberglass castings. 100 feet h x 50 feet w x 50 feet d*

Photo courtesy of Ace Contemporary, Los Angeles, California

was created many, many years later. In *Songs for the Little Ones at Home*, there is a striking depiction from 1852 of children building a snowman. A rare engraving of a snowman appears in the 1838 edition of *The Boy's Book of Sports*.

The word *snowman* became official when it first appeared in the Oxford Dictionary in 1827, after appearing in a shepherd's calendar. But spotting the word *snowman* or *snow puppets* (what they are called in Europe) published anywhere before then is very rare occurrence.

Snowman Deconstructionism was highfalutin stuff reserved for artistes of the day—the aforementioned books and artwork actually had little effect on the snowman entering the public's consciousness by the turn of the twentieth century. Credit for transforming the snowman into a household name goes to two household items that forever changed our society: magazines and cards.

CHAPTER SEVEN

The BIRTH *of a* MEDIA STAR:

1870s–1910s

In the meadow we will build a snowman . . .
—Songsmith Richard Smith, 1934

agazines and greeting cards—before movies, television, and radio, it's how stars were born. Cards were a new, exciting to way to reach people, and magazines had the ability to make anyone (or anything) an instant celebrity. More significantly, however, magazines and printed cards were the first media to show up *inside* people's homes. In the same way MTV changed pop culture in the 80s, the postcard made the likes of Cupid and gnomes into stars. Before this, the publicity machine would have been newspapers, town criers, telegrams, and medicine shows from the back of a Gypsy caravan—a PR nightmare.

Since the magazine's inception, the snowman has landed as many covers as just about anyone. While other celebrities come and go, the snowman has the advantage of never aging and, as they say in publishing, he's an "evergreen," i.e., always hot. He's crossed over

The earliest snowman magazine cover.
Godey's Lady's Book, *1852.*

different genres, appearing on the covers of rap magazines, children's publications, travel magazines, humor titles, adult rags, and family reading. Today there are even snowman craft magazines (e.g., *Snowmen*, published by Primedia), specializing in the art of turning your home into a winter wonderland for the holidays. The snowman has appeared on the cover of *The New Yorker* magazine dozens of times, more than has any other figure. Norman Rockwell painted the snowman for the cover of *The Saturday Evening Post* (twice).

The magazine's boom was a case of the right recipe of perfect ingredients and circumstances. Start with a successful

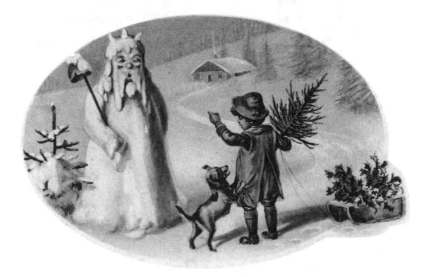

The snowman appeared from 1907 to 1911 as a realistic person many refer to as Father Winter before he rounded out his look again.

Industrial Revolution, then add one part national circulation capability (by means of rail) and one part printing advancement (lowering production costs and improving quality). Combine with a heaping tablespoon of commissioned illustration and a pinch of favorable postal rates. Let cities rise until there is more education, resulting in more literacy. Set aside. Bring a simmering, growing economy to a boil. Place a healthy measure of advertising into the mix to absorb costs and lower the price of magazines to ten cents. Add garnish and extra interest with "muckraking journalism" (thanks to the Progressive Movement). Serves around 76 million.

In 1907, the snowman appeared on the cover of *Pears*—one of the snowman's big breaks in his aforementioned "celebrity arc," explained in The White Trash Years chapter. *Pears* magazine covered pastimes like croquet, baseball, and the ever popular "pig in the parlour," a children's song-game. Landing the cover was validation. Snowman making was *in*. While this newfound attention played a part in his becoming an item of scrutiny among poets and the ever-judgmental public during the era of Snowman Deconstructionism, it gave him the name recognition needed

Titled RECOGNITION. *One of the first times the snowman was widely published. Originally appeared in* Harper's Weekly, *1874.*

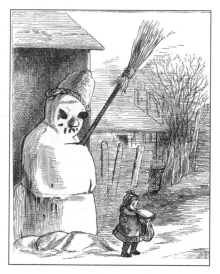

"Oh dear, if it should only move, or say something, I should expire; I know I should." Playing the bad guy in this magazine gig. (1877)

Beautiful Postcard from Belgium, ca. 1910.
The Picturetown Collection

Painting from a children's instructional book. First Book, 1899.

later to wow over the advertising world during the Golden Age of Advertising. Neither era would have happened without this coming-out party, the snowman's cotillion. Earlier magazine gigs include a full-page illustration on February 21, 1874, and his first ever gig on April 4, 1868, as a political cartoon—both in *Harper's*.

While magazines were making their way into our homes, printed cards were circulating everywhere in one of three forms: trade, greeting, and postcards. Trade cards were free, illustrated advertising cards left on store counters. Greeting cards replaced sending letters for the holidays. Postcards came last and were the largest of this group . . . and the most responsible for the snowman's ticket to superstardom.

The coming of the postcard meant the beginning of a new American icon: the snowman. Back then, sending a postcard sometimes took only two or three hours to be delivered, and it was much cheaper than sending regular mail. Next to yelling out the window, it was simply the most popular way people communicated. Everyone relied on the postcard for much of their correspondence, and in its heyday, between 1900 and 1914, a time before television or radio, it became a powerful political and cultural tool as well. The door was open, and opportunity knocked. Postcards needed illustrations that made you laugh and cry and provoked thought. Snowmen were easy to illustrate. Finally there was a perfect vehicle

The earliest picture of anyone making a snowman. From History of British Birds *published in 1797, Thomas Bewick cut this out of wood in the late 1780s. Notice the snowman smoking a pipe and the words on the bottom left, "Esto Perpetua" meaning "Let it endure for ever," a popular motto at the time. The artist was referring to his own artwork as the only way to capture a boy's childhood or snowman's existence.*

By permission of the Special Collections and Archives Librarian,
Robinson Library, University of Newcastle upon Tyne.

to propel the snowman into the twentieth century.

Before postcards, if someone wanted to send a picture of a snowman to a loved one, they would send a greeting card. Greeting cards were America's tastemaker and got the snowman on the map. The father of the American Christmas card, Louis Prang, printed his first cards around 1875, when New Year's was a bigger holiday than Christmas. The cards depicted daisies and apple blossoms—symbols most commonly associated with the holidays—until Santa

Youthful Sports *(1801). Published in London, this rare illustration of snowman making is obviously based on an English engraving made twenty years earlier (above).*

Courtesy of Cotsen Children's Library,
Department of Rare Books and Special Collections,
Princeton University Library

and snowmen entered the scene, helping Christmas take over the number-one spot. America was hooked on Christmas cards (though not Prang's—he was run out of business by 1890).

The oldest and rarest of cards are trade cards, which are similar to business cards but beautifully illustrated. Trade cards were the major way of advertising America's products, and here you find the oldest examples of the snowman as a pitchman. Trade cards became a hot item beginning in 1870, thanks to advancements in color lithography and renowned French artists like Théodore Géricault, Eugène Delacroix, and Honoré Daumier. Later that year, another group of French artists would make the most important snowman ever: a colossal snow sculpture called *La Résistance*, in response to the revolution in Paris. And, by the way, it was a snow*woman*.

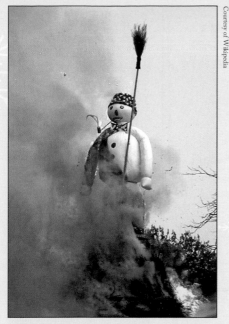

Blowing up snowmen is a legal holiday in Switzerland.

Mascot for the Carnaval de Québec.

The Age of Expansion.

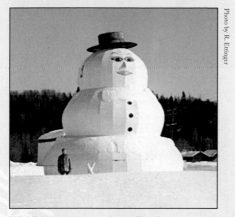

World's largest snowman house. Beardmore, Ontario.

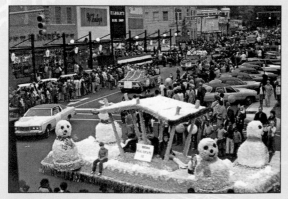

The Ozark, Alabama, Christmas parade.

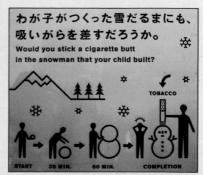

わが子がつくった雪だるまにも、
吸いがらを差すだろうか。

Would you stick a cigarette butt
in the snowman that your child built?

TOBACCO

START　　30 MIN.　　60 MIN.　　COMPLETION

A snowman public service announcement in Japan.

A scene from the Beatles' movie *Help!*, featuring a spy disguised as a snowman.

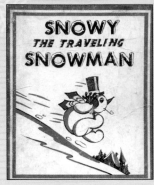

Book by Ruth Burman, 1941, illustrated by Elsa Garratt.

Sheet music from the play *Snowmen on Parade*.

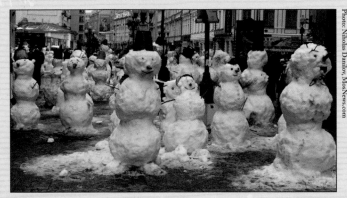

At the 2005 premiere of world-famous clown Vyacheslav Polunin's "Snowshow," ticketholders were greeted by snowmen created by the Academy of Fools. (Part of the final exam for students of the Academy is to make a snowman.)

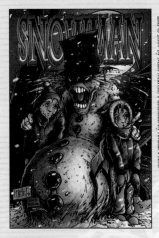

Poo-Pooing Snowman

Everyone poops. Everyone.

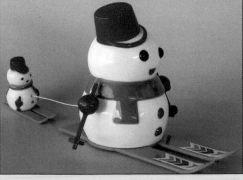

Japanese Toy.

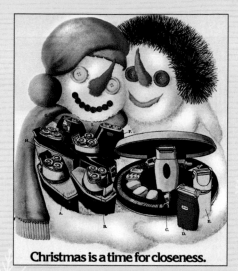

Christmas is a time for closeness.

Ad for Norelco shavers, 1972.

A Happy Winter hand warmer.

Watch Winter Melt Away!

Ad for Vacationland USA, 1970s.

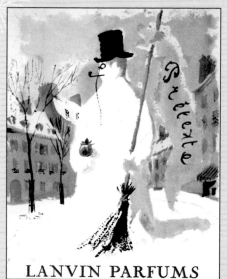

LANVIN PARFUMS

Originally appeared in *Plaisir de France*, 1955.

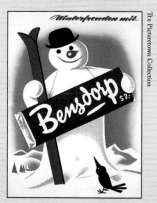

Billboard for Bensdorp chocolate.
Vienna, 1957.

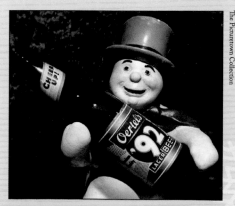

Display for Oertels beer.

Ad for Miller High Life beer.

Early sketch for logo for Frost King, ca. 1950. Created by its president, Mel Gerstein.

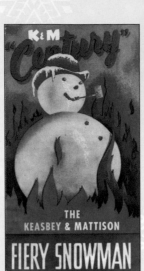

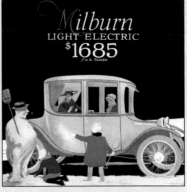

Originally appeared in *The New COUNTRY LIFE*, 1917.

No qualms about selling asbestos for Keasbey & Mattison in the 1930s.

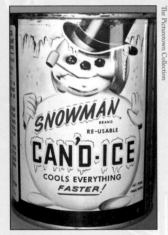

Selling his own flesh and blood in the forties and fifties with a popular product called Snowman's Can'd Ice.

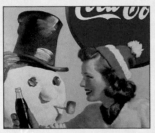

The Real Thing back in 1941 (Coke).

Snowman-brand antifreeze.

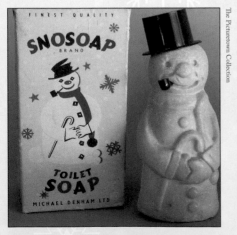

Now you can shower with the snowman. Snosoap.

This snowman brush giveaway from the Fuller Brush Company was good for the religious or for those who believe in good grooming and shiny shoes.

Der Schneemann ist recht fein geworden.
Jetzt hat er auch noch einen Orden.

Loosely translated: "The snowman has become rather fine. Now he has a coffee grinder around his neck."

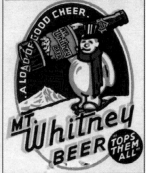

The snowman on a matchbook selling alcohol.

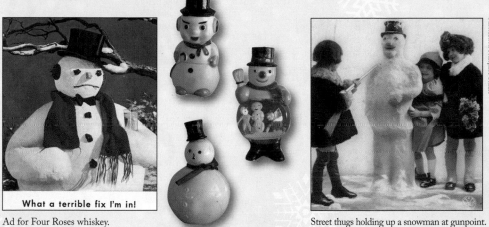

What a terrible fix I'm in!

Ad for Four Roses whiskey.

Street thugs holding up a snowman at gunpoint.

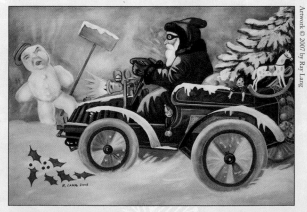

Santa lashing out and driving over a snowman. Painting by Ray Lang is based on rare HTLs ("hold to light" see-through postcard).

FACING A HEAT WAVE!

The snowman on a matchbook selling sex.

David Humphrey. *Snowman in Love*, 2006. Modified inflatable snowmen and paintings.

Gary Hume. *Snowman (Red)*, 1997.

David Humprey. *Snow Guys*, 2006. Acrylic on canvas.

Not Joan Miro's *Blue II* from the triptych *Les trois bleus*, but a dramatization of the still-life he worked from—a melted snowman.

Campaign matchbook for a court clerk.

Beautiful trade cards, a form of business card, predated postcards and were common in the late nineteenth century.

Just your average WWI Christmas card with run-of-the-mill psycho snowman.

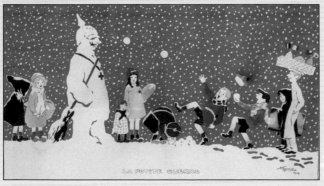

WWI postcard, 1914.

Trade card for McLaughlin's Coffee, 1891.

Rare 1904 greeting card with metallic ink.

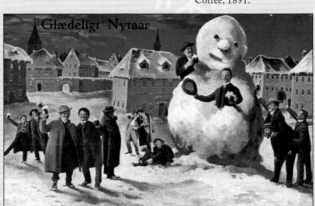

Festive Austrian New Year postcard, 1919.

SNOWMAN PHOTOGRAPHY
since the MID-NINETEENTH
CENTURY: MR. SOUND BITE

The camera adds ten pounds.

—Anonymous

The snowman has always enjoyed a Forrest Gumpian knack for being at the right place at the right time, becoming a staple of mass culture. As an icon of the average Joe, everyone knows posing with a snowman simply makes sense and is good PR. He's been called to duty whenever flag-waving activists cry out for symbolism, whenever the media wants a sound bite, whenever a politician needs a boost in the polls. Although by no means a leader, it's often the snowman left holding the ball, expected to step forward for the sake of the good cause.

During the civil rights movement in the Mississippi Delta, the snowman was left outside as the spokesman for the militant Freedom Labor Union and Ministry in a protest against President Johnson. The president learned in a telegram that the members of the labor union had locked themselves in more than three hundred government buildings only to leave a spokesperson made out of snow. At the entrance of the occupied air force base, the snowman held a sign: "This is our home."

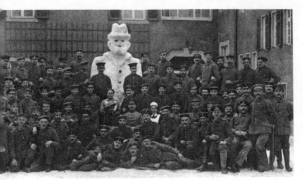

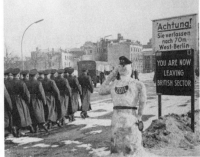

It's clear who the leader is in this group shot of WWI German soldiers. (ca. 1915)

The Picturetown Collection

Soviet Red Army marching into West Germany, 1958.

Courtesy of Bettmann/CORBIS

Public social justice movements are nothing new for the snowman. In 1984, striking miners in England made a snowman wearing a cop's helmet. The chief of police responded to this insult by driving over the snowman at full speed—unaware the snowcop was built over a concrete post, smashing up his Range Rover.

After the first snowfall of the twenty-first century, a Chinese policeman in politically sensitive Tiananmen Square flattened a nonplussed snowman holding the Chinese flag. In Lithuania, as a sign of protest, 141 snowmen were made outside Parliament—one for each member. In that northern European country, the snowman is slang for "a man without brains."

When the United States went to war on January 16, 1991 (for the first time in nearly two decades), there was widespread support and excitement across the country. Patriots altered holiday decorations: In Massachusetts, a snowman sported Marine fatigues, and in Bowling Green, Ohio, a snowman got to drive a snow-tank.

Again, WWI German soldiers elect a snowman as their leader. (1917)

The Picturetown Collection

"To the memory of our reserves in the district commando." German soldiers (1909).

The Picturetown Collection

So while the politically charged snowman was doing photo ops he was also a staple in political cartoons. This one was a greeting card from 1915 and read: "Best Wishes for the New Year from the 11th Corps."

<div align="right">The Picturetown Collection</div>

"The Three Drips" was the title of this cartoon by Walt Ditzen. Originally appeared as an ad for Philco Corporation in LIFE, 1943.

<div align="right">The Picturetown Collection</div>

A VERY RAPID THAW.
SUDDEN MELTING OF THE DEMOCRATIC SNOW MAN.

"Friends, snowmen, and countrymen . . ."

The first published political cartoon with a snowman. "A Very Rapid Thaw; Sudden Melting of the Democratic Snow Man." Harper's Weekly (1868)

<div align="right">The Picturetown Collection</div>

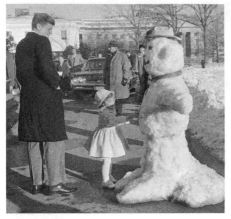

President John F. Kennedy and daughter Caroline exchanging pleasantries with a snowman.

Courtesy of Bettmann/CORBIS

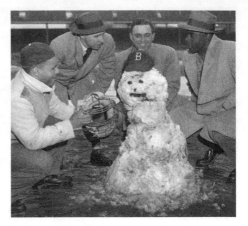

Clockwise from left; Roy Campanella, Captain Pee Wee Reese, a snowman, Gil Hodges, and Jackie Robinson of the Brooklyn Dodgers on the pitcher's mound at Ebbets Field, 1950.

Courtesy of Bettmann/CORBIS

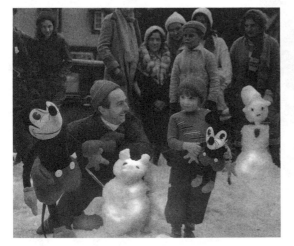

Walt Disney judging a Mickey Mouse snowman building contest at Lake Arrowhead, California, 1933. Photographed on the right is the first place winner, Mildred Lee Canter, with her grand prize, a Mickey Mouse doll.

Courtesy of Bettmann/CORBIS

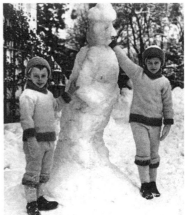

Prince Wilhelm and Prince Louis Ferdinand of Prussia. (1912)

The Picturetown Collection

Amelia Earhart on a bizarre Christmas card. (1936)

The Picturetown Collection

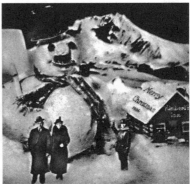

All illustrations on page 75 © 2007 Bob Eckstein except for *The Snowman*, courtesy of Frank Franzetta

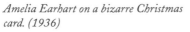

How does the snowman command the attention of so much paparazzi? High VIP quota. To demonstrate, let's employ the mathematical theory-cum-party game, Six Degrees of Separation, which states that any celebrity can be linked to Kevin Bacon in six steps. The object is to make the connection in as few steps as possible. With the snowman, the amount of steps seldom exceeds four. For example:

Actor **KEVIN BACON** was in *Picture Perfect* (1997) with . . . **JENNIFER ANISTON**, from *Friends,* in which she costarred with . . . **COURTENEY COX**, who used to date . . . **MICHAEL KEATON**, who starred in . . . *Jack Frost*, about a **SNOWMAN** (1998).

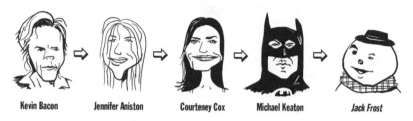

| Kevin Bacon | Jennifer Aniston | Courteney Cox | Michael Keaton | Jack Frost |

It works backward, too:

THE SNOWMAN in *Rudolph, the Red-Nosed Reindeer* was played by . . . **BURL IVES**, who was in *Ensign Pulver* (1964), with . . . **JACK NICHOLSON**, who starred in *A Few Good Men* (1992) with, you guessed it . . . actor **KEVIN BACON**.

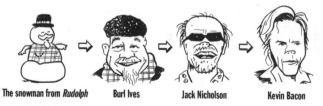

The snowman from *Rudolph* Burl Ives Jack Nicholson Kevin Bacon

Actually, it will work with anyone:

PRESIDENT GEORGE W. BUSH lives in the White House. One person who has expressed interest in moving there is . . . Governor of California **ARNOLD**

George W. Bush Arnold Schwarzenegger Conan the Barbarian Frank Franzetta's *The Snowman*

SCHWARZENEGGER, who starred in . . . *Conan the Barbarian*, which was the creation of painter and *Heavy Metal* illustrator . . . **FRANK FRAZETTA**, whose first professional comic story was . . . *The Snowman*, created at age sixteen.

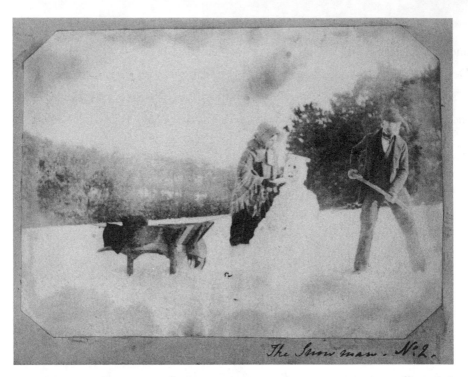

The very first photograph of a snowman. By photography pioneer Mary Dillwyn. (ca. 1845)
By permission of Llyfrgell Genedlaethol Cymru/The National Library of Wales

The snowman found himself right in front of the camera lens even at the birth of photography in the 1840s—yet another example of the snowman's uncanny ability for being present for man's most important advancements.

In Swansea, Wales, a young woman named Mary Dillwyn made a little photo album as a gift for her disabled niece. This collection of forty-two salt prints came

Photograph from 1902.
The Picturetown Collection

back to Mary when her niece passed away at age twenty-four. The photo album stayed in the Dillwyn family for over one hundred years. (It went on public display for the first time when, in 2002, the National Library at Aberystwyth purchased the small collection for $77,344.)

Mary Dillwyn was one of the pioneers of photography, and her rare album was likely

the first of its kind to use photography as an art form, including what is probably the earliest photo of a person smiling. Early cameras required the sitter to remain motionless for minutes at a time, enough to tire most people's facial muscles. This was before professionals got paid to smile à la Vanna White, Katie Couric, etc. Holding a smile that long was unheard of. Combined with bad teeth and social customs that frowned on being candid, the first photographs often depict subjects with serious expressions.

Mary, however, had one of the first small cameras with a short exposure, enabling her to document such fleeting moments as a child's smile, a fast-moving chicken, or spontaneous family moments. Mary's collection includes two startlingly powerful images of the erection of a snowman. No one had ever seen this on film before. Mary Dillwyn's photographic prints were testimony to the aesthetic application to this new scientific and technical process.

Following her marriage to a reverend in 1857 and because of her distaste at photography's increasing commercialism, Mary never took another photo of a snowman again and gave up photography forever.

Any two-dimensional artwork of a snowman before this time is not only either a drawing or painting . . . it is extremely rare.

Very early photograph of a family having fun in the snow with their snowman. (ca. 1880)

The Picturetown Collection

"I love your nose."

A Comic Interlude of *the* BEST SNOWMAN CARTOONS

"Frosty in Bed" *You: Fun, outdoors type, open-minded. Me: Inanimate snowman. I dislike head games, smokers, dogs, and temperate climates.*

—Personal ad

This interlude is a subjective collection of the best snowman cartoons appearing in both newspapers and popular magazines. Recently, the snowman has enjoyed resurgence partly in thanks to his frequent appearance in the Calvin & Hobbes cartoon strip. But the snowman has always been quite popular in the funnies. Is there a better foil, a better fall guy? And it is very popular with cartoonists— is there anything quicker and easier to draw than the snowman? Of course, time is money.

"Good news—those lumps were just coal."

THE VILLAGE SNOWIDIOT

"You can stop staring. You know, they're not real."

"Nobody move! I think I lost an eye."

"It took a long time before I could look myself in the mirror and say, 'I'm Frosty the Snowman, and I like me.'"

Scott finds out Amundsen got to the Pole first.

83

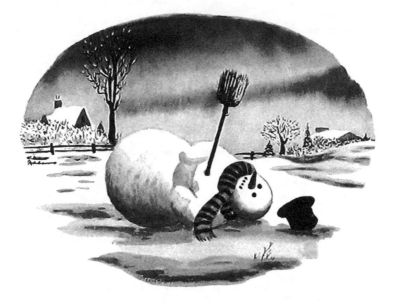

Charles Addams © Tee and Charles Addams foundation

Reprinted with permission courtesy Creators Syndicate.
© Leigh Rubin

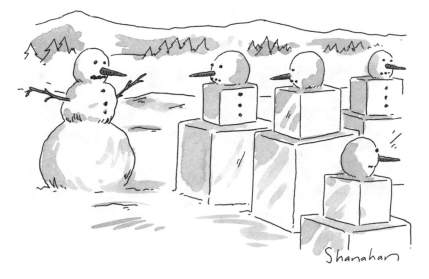

"Nobody told me it was formal!"

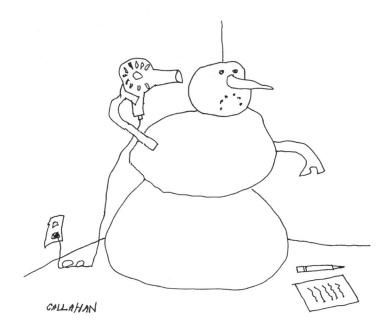

"Well, now, what have you two been doing all day?"

PART TWO

The RENAISSANCE SNOWMAN

Ghostly, rotundly metaphysical; fluid though crystalline; frozen yet malleable; he is at once tabula rasa and our own destiny writ large.

—Mark Kalinoski, snowman theoretician

From outward appearances, the Renaissance Snowman looks very different from your garden variety "Modern" snowman. You may ask, where's the carrot? No scarf?! What's with all the details and contours? Why the futzing around? Too good for just stacking up three very large snowballs? Many are saying, "If it's not broke . . ." Well, it's not that simple.

Renaissance Snowmen go back to a time when snowmen, more often than not, were created by artists striving toward making works of art; as a result, snowman makers put considerable time and effort into the craftsmanship of snowmanship. Sometimes the process included adding water, freezing the snow, and using tools to *sculpt* the snow (not to be confused with ice sculpture, which begins with

a block of ice and involves chainsawing or chiseling away the form like a marble sculpture).

But what really defines Renaissance Snowmen is that they are conceptual. They were snowmen built with a purpose and were modeled by throwback artists—old school—to make a statement. As we travel back through the Middle Ages on our way toward the Dark Ages, historical documentation dissipates. The Renaissance Snowman becomes increasingly difficult to find. Scarce references are hidden in chronicles and diaries scrolled in Old English or Old Dutch with maddening verbiage. What little can be deciphered is skewed by medieval mentality and the understanding that half the population in the Middle Ages was nuts, brought on by illness and starvation. No wonder the Renaissance Snowman managed to elude Google. Visiting Renaissance Snowmen's cities of origin is the only way to find them (especially since many museum curators are not aware that their archives contains clues to ancient snowmen). Nevertheless, there *are* clues—you just have to know where to look.

A well-executed example of snowman making as art.
The Picturetown Collection

The snowman has many skeletons in his closet.
The Picturetown Collection

The REVOLUTION *of* 1870:
THE SNOWMAN'S FRENCH ROLL

If but a dozen French were there in arms, they would be as a call
To train ten thousand English to their side,
Or as a little snow, tumbled about,
Anon becomes a mountain.
　　　　　　　—William Shakespeare, *The Life and Death of King John*

L ate-nineteenth-century Paris, the fashion capital of the world, predictably hosted the best-dressed snowmen in the world. When noted prude Madame de La Bresse passed away in 1876, she instructed in her will that all 125,000 francs (about $22,500 today) of her fortune were to only be spent putting clothes on the vulgar and offensive naked snowmen in the streets. This bizarre bequest may have had something to do with a certain celebrated snow statue made during the later part of her life in 1870. What started out as a group of soldiers taking a break on the battlefield would come to be known as *The Musée de Neige at Bistion 84* (*The Museum of Snow*). Although crafted in a mere two to three hours, the centerpiece was a colossal snow sculpture called *La Résistance*, a French snow woman and the most important snowman

ever made. This provocative snow sculpture became a powerful piece of art with far-reaching artistic and political influences and was a historical event in its own right.

The Seventh Company (of the nineteenth battalion) of the French National Guard, stationed at the southern edge of Paris during the Prussian attack in December 1870, was a regular "who's who" of French pop culture: artists Alexandre Falguière (renowned sculptor of *Joan of Arc*), Hippolyte Moulin (famous for his sculpture *A Lucky Find at Pompeii*), Henri-Michel-Antoine Chapu (painter of *Jeanne d'Arc*), Eugéne Delaplanche (along with Falguiére, part of the artists called Les Florentins), and Auguste Lepére (the world-famous engraver). Also in this troop was: musician M. Leneveu, engraver Desmadryl, and painters M. M. Chenavard, Carolus-Duran, Auguste Toulmouche, Emmanuel Lansyer, Louis-Eugène Lambert, and E. Oudinot.

La statue de la Résistance, par Falguière *by Félix Bracquemond, 1870.*

The date was December 8, 1870. Snow began to cover Paris. Bored officers threw snowballs, and some of the soldier-artists began to make snow sculptures. Before long, the snowballs became monumental snow statues. One soldier, Alexandre Falguière, channeled his angst of his home city being attacked by creating *La Résistance*, a colossal snow woman, which was constructed in a mere two to three hours with the help of others.

Although the artist Moulin built a huge snow-bust nearby, it was twenty-nine-year-old Falguière's snow woman that attracted the press

to visit the site. Beautiful in its own right, it also captured a moment of pride and angst, a rallying cry for this turbulent time in France. Falguière's real coup was the inventive act of both sculpting a snow figure to represent the plight of the French and simultaneously turning it into a celebrated event. Groundbreaking not just because Falguière used snow, but because he allowed a female nude to represent the concept of *La Résistance* abstractly. The new symbol was quickly reproduced in *L'Illustration* magazine. Accompanying the illustration was a flattering essay by critic Théophile Gautier, who, like many others, made a special trip to see the *Musée de Neige*. The political ad conjured this defiant gesture by marrying a political statement with the female form—one that was both nude and totally brazen. During this particular era, artists rarely created nudes, even indoors. The three firsthand accounts agree that Falguière depicted the figure androgynously.

The snow woman was light in the bosom yet clearly blessed with a female face. She had broad shoulders with folded muscular arms and possessed an able-bodied, World Wrestling Federation savoir faire, which suggests Falguière compared the Prussian siege of Paris with the sexual aggression of a relentless female refusing to succumb (*La Résistance*).

Although Falguière was already a star at the Salon when he made *La Résistance*, it was a crucial moment for him. The snow sculpture was Falguière's very first female nude, a subject he would become known for—and stay fixated on the rest of his career.

One art historian speculated that Falguière was coaxed into choosing a nude as his subject by his "playful, if not vulgar" comrades. There is, no doubt, a kernel of truth in this. After all, *La Résistance* was a nine-foot naked female surrounded by forty men. Surely there was a little hooting and hollering to keep her snow clothes off—one of the drawings depicts a spectator groping the snow woman. In any case, this was Falguière's first time sculpting a female. While Falguière *was* interested in conveying strength, the very Michelangelo/Rodin muscles and lines are at least partly due to lack of experience and disappeared in his subsequent females. Other factors may have come into play as to how the finished piece came to be. Falguière

may have chosen the usually manly gesture of crossed arms because it would be difficult to create extended arms of snow. Falguière may have played down the erotic parts to avoid riling up the all-male troops—when he later re-created the image in stone, in the process sacrificing a great deal of the sculpture's charm, as the figure became softer, more feminine.

The artist Félix Philippoteaux, who belonged to the same company, made a sketch of the snow woman at the time. Later, many artists would re-create Falguière's snowman using all sorts of different materials besides snow. Burn Smeeton rendered an engraving based on the Philippoteaux sketch, which was published days later on New Year's Eve of 1870 in the art magazine *L'Illustration*. Gautier's pupil Théodore de Banville published a poem about the snow figure. Félix

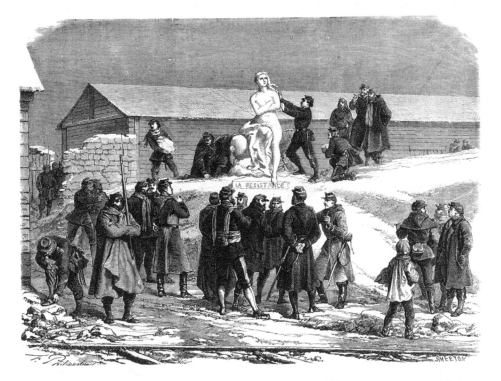

Engraving by Burn Smeeton in 1870 based on a drawing by Félix Philippoteaux. Initially published in 31 December 1870 issue of L'Illustration.

Bracquemond, an important printmaker, made an etching, which the caricaturist Faustin included in *Paris Bloqué*, a series of lithographs.

According to Gautier, Falguière himself had promised to make a copy of his snow figure "to conserve its expression and movement" as soon as he finished serving his term in the Garde nationale. But in June 1872, at the first Paris Salon show since the war, critics were disappointed to see the sculpture had still not been "solidified in plaster or marble." It would never appear at the Salon. Critic H. Galli wrote in 1895 in *L'Art Français*:

> *As soon as Falguière was back in his studio, he took up his modeling knife, but he sought, worked, and suffered in vain. None of his maquettes had the proud allure, the poetry of his snow statue; he destroyed them. The capitulation, the dismemberment of France, and then the awful civil war had, alas, dissipated his last hopes. The inspiration was dead.*

Recapturing that magic would prove to be impossible for the unflagging Falguière. Eventually he created many variations in wax, plaster, terra cotta, and bronze, ranging in size from two to four feet high, all less successful than the original snow sculpture. Falguière could never duplicate the spontaneity and urgency of that long gone snow woman. That moment had passed and had melted along with his original masterpiece.

Snowman (or woman) making is many things and is always, if anything, an art of the moment. No one reworks his or her snowman, and there is no wastebasket in which to toss rejects. It is one thing to sculpt a clay nude in the privacy of one's studio, but it is quite another to shape the contours of a woman outdoors in a snowstorm, near the front line, in front of a crowd. The particular qualities of Falguière's first sculpture, a mixture of eroticism with physical and psychological severity, could not be repeated.

MADE *in* AMERICA:
THE SNOW ANGEL OF 1856

The statue got me high.

—*They Might Be Giants*

*All the people are so happy now, their heads are caving in
I'm glad they are a snowman with protective rubber skin.*

—*They Might Be Giants*

N ever before had the decision to go out and make a snowman changed one man's life so dramatically. On New Year's Eve of 1856, a young artist and a couple of buddies in Brattleboro, Vermont, made a snow sculpture that by the next morning would launch the career of one of America's most important sculptors. Their snowman was actually a snow woman and was affectionately called *The Snow Angel*.

Walking down Main Street today, one can spot the back of a small statue through the front window of the Brooks Memorial Public Library. Once inside this town library, the front of the sculpture becomes clear—a beautiful delicate angel, the size of a small child. It

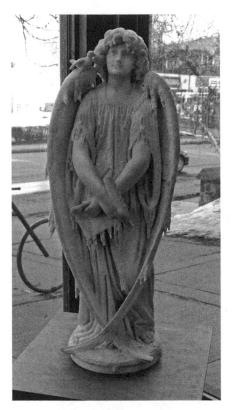

The Snow Angel marble replica made in 1886 on display at the Brooks Memorial Library. The year before, Harper's Weekly *devoted a full page to "The Snow Angel," complete with illustration and poem.*

Courtesy of Special Collections of
Brooks Memorial Library, Brattleboro, Vermont

rests inconspicuously near the perpetual cluster of patrons thumbing through the magazines or looking for a good video to take home. Made of marble in 1886 by Larkin Mead, it's only a replica, made thirty years after his grander feat, the celebrated *Snow Angel*, which he made of snow across the street. In the general area where she stood over one hundred years ago, there is now a monument called *The Wells Fountain*. Designed and constructed in 1890 by Mead's younger brother, William, the water fountain was to commemorate *The Snow Angel*, and a clever nod to the long melted snow woman.

By the time Larkin G. Mead, Jr., died in Florence, in 1910, he was world famous. Although he was buried in Italy and spent most his life there, he was best known for his American monuments and memorials. Right before he died, he had returned with his wife by ship to his hometown of Brattleboro. Mead had not been back to America in thirty years. The homecoming was big news for the area, and the local papers followed their hometown hero's every step. Townspeople still fondly remembered and talked about *The Snow Angel*. The eight-foot-tall snow statue was Mead's most beloved piece and had catapulted his career. While the Angel was made in one night, Mead's most famous work and his most scrutinized undertaking, the Lincoln Memorial, in Springfield, Illinois, took six years to complete.

At the beginning of the Civil War in 1861, Larkin Mead (along with other notable artists like Winslow Homer) was hired by *Harper's Weekly* for forty dollars a week to illustrate what was going on at the front. *Harper's* was a pioneer and the first of its kind to run engraved illustrations. For the first time in history, people far from the frontlines could read the descriptions and see the images of a war almost as it was happening. The breakout of war interrupted a wave of commissions Mead enjoyed, including a marble likeness of Ethan Allen for the capitol building and a sculpture of the Greek goddess Ceres to go on display at the Vermont State House—both a direct result of *The Snow Angel*. But the most popular request was for replicas of the angel.

In an early letter (1857), a family friend wrote, *"Larkin Mead's snow statue is opening the way to a fine career as an artist. Mr. Longworth . . . promises to send him to Florence . . . He also has engaged him to execute a full-sized marble statue of the snow work. This is all a secret between the old gentleman and the boy . . ."*

Larkin's future was etched in stone on that fateful New Year's Day in 1857—waiting at dawn for the town of Brattleboro was a masterpiece. The town's reaction was reported by the *Vermont Phoenix*:

The inhabitants of the village discovered "The Snow Angel," in the prismatic glow of the morning sun's reflection. The early risers and pedestrians about town were amazed, when they drew near, to see what appeared at a distance like a school-boy's work turned to a statue of such exquisite contour and grace of form . . . The passing school-boy was awed for once, as he viewed the result of adept handling of the elements with which he was so roughly familiar, and the thought of snowballing so beautiful an object could never have dwelt in his mind. It is related that the village simpleton was frightened and ran away, and one eccentric citizen, who rarely deigned to bow to his fellow men, or women either, lifted his hat in respect after he had gazed a moment upon Mead's work.

Initially, no one knew who was responsible for the statue, and townspeople credited it as the work of an angel. The curious traveled far to see the spectacle.

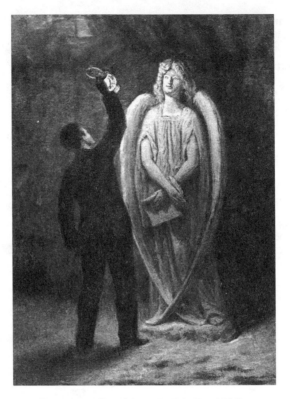

The event achieved almost instant national recognition, and even the *New York Tribune* covered the story. Eventually, the statue received notice in publications around the world. Although hundreds of people eventually visited the monument, awe-inspired respect protected it, at least until the annual January thaw.

It was New Year's Eve of 1856 when Mead went outside and began creating a snowman that propelled him into world fame. The concept of the piece, appropriately enough, was to make a "recording angel," the mythical figure with a pen and tablet who keeps track of the year's events at the close of each year. He was helped by two brothers, employees of his at the drawing school he had opened on

the same corner. It was they, Edward and Henry Burham, who convinced Larkin Mead to try his hand at this undertaking. Working with snow, Larkin and Edward molded the figure by hand (not with ice chisels) and formed the features with the help of water. Henry helped by providing a constant flow of alcohol from a neighboring foundry, where the snowman makers took occasional breaks from the bitter cold, sitting next to a fire drinking sweet cider. The three worked till dawn.

While Mead's snow angel sounds like the makings of the first idyllic snowman— something straight from a Currier & Ives print—long before *The Snow Angel*, artists in Europe made similar masterpieces. There, the snowman carried no stigma of being too pedestrian for the established respected artist, and sculptors paid as much attention to detail as if they were working in marble.

ELLERY & WILSON 505 GRAND ST. N.Y.

One of the first trade cards.

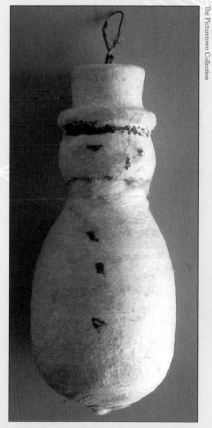

Rare German hand-spun cotton Christmas
ornament that, inexplicably, goes for hundreds
of dollars in online auctions.

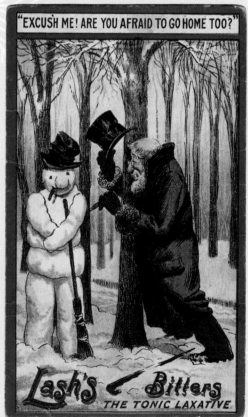

"EXCUSH ME! ARE YOU AFRAID TO GO HOME TOO?"

Lash's Bitters
THE TONIC LAXATIVE

A laxatives trade card.

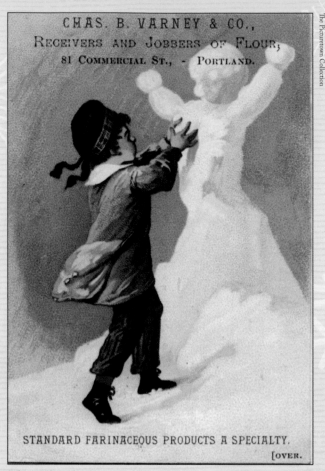

A flour trade card.

This illustration drawn by John Hassall is from "The story of a Snow Man: Showing How Vice is Ever Overthrown," published in *The Graphic Christmas* magazine, 1905.

Early engraving of yesteryear's winter pastimes.

Hartelijke Gelukwensch.

Basking in the glow of his newfound stardom.

A MERRY CHRISTMAS TO YOU

Early examples of misguided youths taking out their angst on the snowman.

Unusual and exceptionally early trade card advertising for Crowe's Suit and Cloak Establishment, formerly located at 257 Sixth Avenue in New York City.

Old greeting card from Woolson Spice, which included these picture cards inside their bags of coffee.

The sledder seems to be miffed by the presence of unidentified man with the snowman. Possibly an agent?

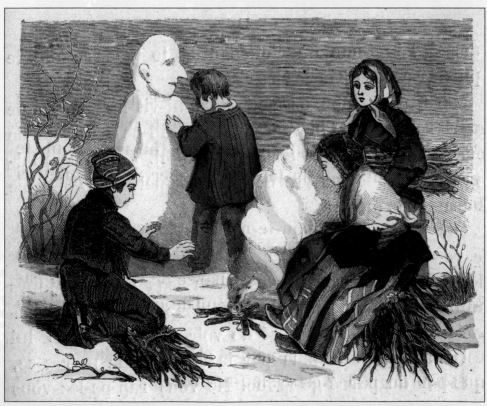

From a French children's book appropriately called *Historiettes Amusantes*, meaning *History of Amusements*.

Detail of Pieter Huys's *Le Jugement dernier* (1554), with heaven depicted as a kind of enormous igloo.

Marginal illustration from *Book of Hours*, ca. 1380. The first recorded snowman ever.

De Sneeuwvesting.

"Snowman making."

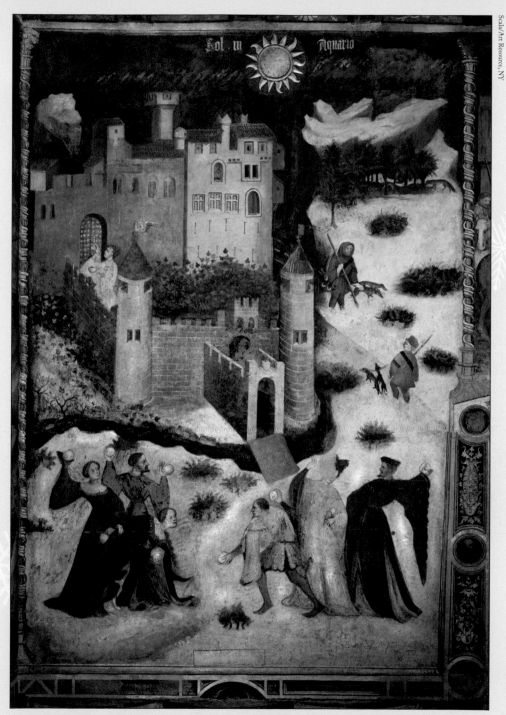

January 1403, Anonymous. This fresco in the Italian castle *Castillo del Buonconsiglio* is the first large representation of a snow scene (or snowball fight) in the history of Western painting. We're not the only animals to make snowballs, but humans are the only animals that throw them. Note that in the scene the lady on the right is getting smacked in the face.

The Japanese tradition of lighting candles inside snowmen's stomachs.

Preview of global warming? No, the AMAFCA (Albuquerque Metropolitan Arroyo Flood Control Authority) tumbleweed snowman appears each holiday season in Albuquerque, New Mexico.

A Japanese print showing the art of making a *yukidaruma*.

EIGHTEENTH-CENTURY SNOW *and* ICE SCULPTURE:
FROM RUSSIA WITH LOVE HANDLES

She treats me far too frosty. . . .

Why does she treat me like a snowman?
<div align="right">—XTC, "Snowman"</div>

In the yard across the street we saw a snowman holding a garbage can lid smashed into a likeness of the mad English king, George the Third.
<div align="right">—Poet Kenneth Koch, *You Were Wearing*</div>

While many North American cities are known for their elaborate ice palaces—Quebec City, Montreal, St. Paul, to name a few—it was Russia that first mastered and exercised this high-brow craft to the hilt as part of their winter festival, Maslenitsa, starting January 6 and continuing until Lent. The Russians commissioned premier artists to create the optimum snowmen to adorn those majestic ice palaces, the hottest architecture of the time.

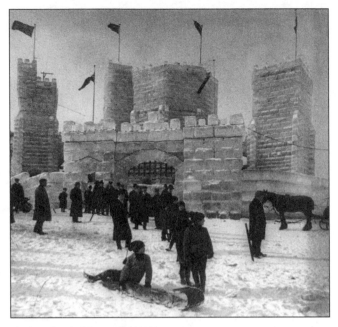

An ice palace in Montreal. (1909)

The most popular of the Russian holidays, Maslenitsa was the celebration of butter. Many can't believe it's butter, but butter was big and so was the party theme with revelers feasting on baked goods loaded with butter. Held as a diversion for the public from the harsh winters, the highlight of this holiday was its monumental ice palaces furnished with objects of everyday life, all made of ice. As the Russian empire grew, so did the size of their frozen castles. The snowmen, which guarded these palaces, were noteworthy for their highly decorative quality.

The basis for the first documented ice palace was the setting for a cruel, monstrous joke. Like her uncle, Peter the Great, the empress Anna Ivanovna had a malicious sense of humor and kept herself entertained by a troupe of dwarves, deformed people, and idiots. A very tall, obese woman, Anna of Russia enjoyed eating, riding (unfortunate) horses, and keeping loaded guns at the windows of her bedroom so she could shoot down birds.

Anna had just spent the fall of 1739 conducting two sets of bloody political executions, and as an encore, she undertook a project that guaranteed her a place

in architectural and sadist history. She commissioned an architect named Piotr Eropkin to build her an ice palace for an arranged marriage between the out-of-favor widower Prince Mikhail, who was in the doghouse for initially marrying a Catholic, and her ugliest servant, nicknamed Buzhenina (which is roast pork with a vinegar and onion sauce, Anna's favorite dish). The two would marry and spend a shivering wedding night in a building of ice.

Laborers constructed the enormous building during one of the coldest winters in history on the frozen River Neva—birds flying over Siberia dropped dead out of the sky. On the positive side, it was said that the ice of St. Petersburg "stimulated a number of inquiring minds to practice their art on this material." Perfect, because hundreds of artists and serf artisans were put to work on the project.

The ice palace was twenty-one feet high, fifty-four feet long, and seventeen feet wide, with an adjacent bathhouse made of ice logs. Six snowmen depicted as either soldiers or nudes flanked the entrance along with a working dolphin water fountain and a seven-foot-long lion. Architects used only the finest ice available—carefully chosen, exceptionally clear blue ice harvested from the Neva. The ice blocks were placed by cranes and attached by brushing water on the joints. Artisans painted the window frames, doors, and pillars green to look like marble. Windows of very thin ice were backlit with candles. Ice birds perched on twenty-nine ice trees tinted in realistic colors. Somehow, a life-size ice elephant fountain sprayed water twenty-four feet high (it's unclear how or why the spouting water from the elephant's trunk did not freeze). For sound effects, a musician played the trumpet from within the vast cavity of the ice elephant. Inside awaited an ice kitchen, completely stocked with an ice tea service, cups, glasses, and colored

Drawings of the working water fountains.

The wedding procession of 1740.

replicas of plated dishes. The honeymoon suite had an ice canopy bed, complete with mattress, quilt, and two pillows—all ice. For dramatic effect, the ice fireplace worked by lighting petroleum-doused logs. Frozen nightcaps were laid out along with two pairs of ice slippers for the unlucky couple.

The centerpiece was a working transparent clock with its interior ice mechanisms on display on an ice table in the middle of the drawing room. And what honeymoon would be complete without six workable cannons (all made of ice) going off in front of stunned visitors. Though frequently fired with one-quarter pound of gunpowder to blast each snowball, no spectators or the weapon itself were injured. The only object in the house not made of ice and snow was a deck of playing cards.

The whole event was a big hit. Eyewitness accounts say the wedding procession began with the bride and groom, dressed in fur coats, hats, and muffs, seated in an iron cage resting atop a real elephant. Dwarves, cripples, and any ethnic minorities despised by the Russian Eastern Orthodox Church followed the bride and groom. Those in the misfit motorcade rode camels or horses or rode in sleds drawn by reindeer, oxen, dogs, rams, bears, wolves, or pigs. The crowds threw handmade toys at the procession while others sang and played musical instruments.

The public did not perceive this spectacle as mean or tasteless but rather

entertaining and good, clean fun. After a religious ceremony, the parade regrouped and trailed the newlyweds to their ice palace, which was all lit up inside with candles. Wooden fencing controlled the overwhelming crowds. Guards ensured that neither newlywed escaped the bedroom. Although some historical accounts stretched the truth and regaled that the bride and groom froze to death by the morning, the prince and his bride not only survived but remained married and later gave birth to twins.

The architect, on the other hand, was not so lucky. The government condemned Piotr Eropkin to death for treason along with one of the ice palace organizers, cabinet minister d'Arlémi Volynski. Executioners cut out Volynski's tongue, then impaled and quartered him alive before beheading him. Eropkin was lucky: He was just beheaded. On the day of their execution at the end of June, all that remained of the ice mansion were floating blocks of ice in the River Neva and whichever parts of the castle that had been dismantled and stored in the Imperial Palace's ice cellar to sell to warmer locations. Ice was expensive—as high as $1.25 a block in hot years; in 1740, that was something like $800 an ice cube. Making a snowman in any of those warmer locations would have been like making a snowman out of caviar.

The jovial spirit of the beautiful palace was long gone. Later that same year, the empress Anna died of kidney disease, and any mention of those responsible for the wedding ice palace became both taboo and illegal, earning you a one-way ticket to Siberia.

Early American Snowmen
in the Seventeenth Century:
New World, Fresh Snow

Out of the bosom of the Air,
Out of the cloud-folds of her garments shaken,
Over the woodlands brown and bare,
Over the harvest-fields forsaken,
Silent, and soft, and slow
Descends the snow.
—Henry Wadsworth Longfellow, *Snow-Flakes*, 1863

hat happened to good old-fashioned snowmen made from simple snowballs? While French and Russia were reaching new heights in perishable sculpture, over in the New World, some were using the snowball in both art and war. After all, it was a snowball that triggered the Boston Massacre of 1770.

The king and the British Parliament passed the Quartering Act in 1767, which forced Americans to take British soldiers into their homes. This was a recipe for trouble. One cold winter night in 1770, a crowd of Bostonians began to make fun of a soldier on duty.

The teasing escalated into snowball throwing. Nearby soldiers came over to help when one of them was hit in the face by a snowball hardened with ice, a "soaker." The soldier retaliated by firing his musket into the mob. Soon, the other soldiers followed suit. When the gun smoke cleared, ten Americans were shot, five of them fatally—the first bloodshed ever between Britain and America.

Snowballs were a bigger problem centuries ago and were frequently blamed for violence. From an 1838 newspaper: "Snowballing could become especially vicious in urban areas during the Christmas season, respectable citizens associated it with the kind of menacing behavior they feared from working-class youth gangs . . ." The holiday season has come a long way from the heavy drinking, high-crime days when Christmas caroling included barging into strangers' homes and "helping yourself."

But what about snowmen? Forty-nine years before Empress Anna's frozen house of horrors, some historians allege that a snowman was made in the New World. Was the first snowman in America made in Schenectady, New York, on the eve of one of the bloodiest days in early American history? What exactly transpired one tragic evening, which would come to be known as the Massacre of 1690, is still a matter of contention. The details of this event have been rewritten many times in the form of poem, song, and history books, based mostly on rumor—often done to suit the desires of different political sides at work.

In 1690, French Canadian soldiers and Sault and Algonquin Indians planned to attack the village of Dutch Schenectady. Those who lived in this outpost had no idea that hundreds of miles north of them, their fate was being decided in Montreal. Traveling nine days in knee-deep slushy snow in snowshoes down the Mohawk Valley, 210 attackers came within sight of the town on February 8. The trip was so strenuous that they were prepared to surrender if there was any resistance. It was eleven o'clock at night and a blizzard had kicked in. The initial plan was to attack at two o' clock in the morning, but the war party acted fast, as temperatures were dropping and the north gate was surprisingly open.

This was a town with over four hundred residents, most of them children. The

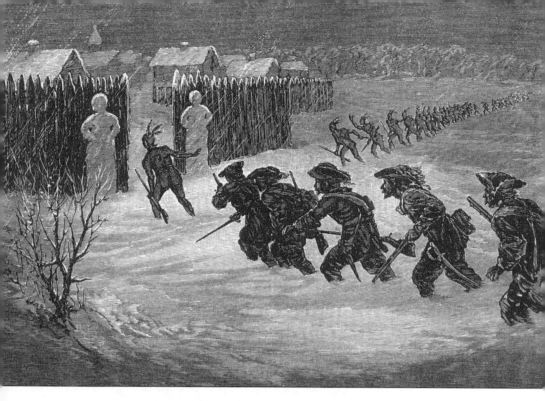

The Massacre of 1690. French and Indians attack on Schenectady, New York.

streets were filled with shops and surrounded by eighty homes, all confined in a tall stockade fort with two gated entrances. Around 1690, that part of upstate New York would have been one of the farthest outposts from white civilization, and settlers lived in constant fear of the unknown. Most of the settlers were Dutch, and they hated the English captain John Sander Glen, who commanded the township. The villagers ignored his advice, leaving their gates open during the snowstorm. According to historian Nathaniel Bartlett Sylvester from *History of Saratoga County* (1878): "[villagers] ridiculed him and placed a snow image as mock sentinel . . . before the open gate, its blind and dumb warder [the snowmen], stood the French and Indians."

Records indicate that the Douwe Aukes' Tavern was the center of most of the ruckus and riots inside Fort Schenectady, and on the night of the massacre this is where the two AWOL guards could be found, drinking, instead of guarding the north gate. While they were partying, 114 Frenchmen and ninety-six Indians

waltzed into Fort Schenectady and, in two hours, killed sixty villagers.

Were two snowmen really left to guard the lives of early Schenectady? Was this just a portion of the story that storytellers later embellished? One point agreed on is that the gate was stuck open from the snow and that it was wrongly assumed that no human would be traveling under such bad weather, enemy or otherwise (although there had been raids in midwinter before, in three to six feet of snow). Nobody would have wanted to stand guard—several sources cited high winds—let alone "[stay] outside to make snowmen out of militia defiance," as reported by one historian (any snowmen would have been made in daylight before the storm got too unbearable). It's possible that villagers made these snowmen as a thumbing of the nose to warnings from the English. In another account, historian Sylvester wrote that ". . . although the Schenectady burghers knew there was danger of attack, the open gates of the town were guarded only by the snow men the village boys had made at the portals." It probably wasn't so much arrogance as it was hatred for the English authority that motivated the residents of Schenectady.

There exists no primary source that reveals who had made the snowmen; even Sylvester assembled his evidence from secondhand accounts. No French officer wrote of seeing snowmen—but then again, it was pitch-black: "The attackers snuck in during the dead of night without torch."

While the snowman portion of this tragedy reeks of finger pointing and fatal oversight, reasoning would have it that there's a kernel of truth here. Certainly, *someone* made a snow figure. Why else would a storyteller add such a trivializing detail to an otherwise brutal event? No one slanders a person by falsely accusing them of making a snowman, of all things. Almost every historic source corroborates the snowman detail. We'll never know whether this was the first American snowman, but the Schenectady Snowman is definitely the earliest *reference* to one.

SNOWMAN EXPLORATION *in* *the* LATE SIXTEENTH CENTURY

Announced by all the trumpets of the sky, Arrives the snow . . .
Come, see the north-wind's masonry, Out of an unseen quarry
evermore.

—Ralph Waldo Emerson, *The Snow-Storm*

When the trail for the snowman goes cold, where do you go? Common sense says you follow the snow. You look to those in the polar regions— the Eskimos, the Inuits, maybe the small handful of arctic explorers. Fortunately for us, explorers tend to keep records, logs, diaries, and collect artifacts and fossils. Voyages to the edges of the world were undertaken for the advancement of natural history, astronomy, navigation, hydrography, meteorology, electricity, and magnetism. But way back in the late sixteenth century, when some of these branches of science didn't even exist yet, explorers were more like entrepreneurs, looking to claim land and trade with Asia. Particularly India. English merchants/explorers spent many a sleepless night—like Ralph Kramden scheming a get-rich-quick

One of the drawings from Gerrit de Veer's journal telling home of the unusual world beyond the horizon. (1599)

plan—cooking up a shortcut to India. Without a decent map or desk globe, it really was guesswork in 1550 when the Portuguese decided (or rather, it should be said, the Pope decided for them) to sail west around the bottom of Africa. Meanwhile, the Spanish sailed east . . . only to run into America. The French did likewise in 1524. (The most preposterous attempt to reach Indonesia, in hindsight, was Sebastian Cabot's. He left Bristol, England, heading in the direction of Quebec, making changeovers in what would later become Labrador and Virginia. Not even close.)

Whichever direction they went, most explorers found themselves in snowy regions (probably to the surprise of sailors who expected to find a temperate "paradise" near the North Pole). Did the Europeans discover snowmen in these new lands? Did the natives they met create their likeness in the snow? We know sailors in the seventeenth and eighteenth centuries made snowmen right onboard their ships. One story, dating back to 1851, tells of the crew of the *Pioneer* who entertained themselves while trapped in ice floes near Greenland by building snow sculptures—including a notable statue of Britannia, the national symbol of Britain (the seated young woman holding a spear and shield seen on their money).

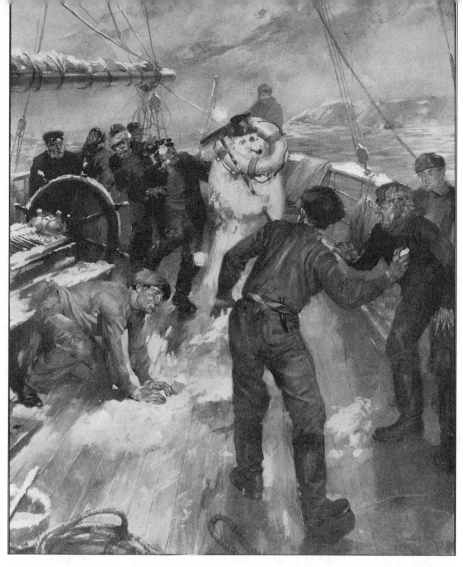

"In drifting flakes he came aboard. And on the deck he laid him down; We gave him shape, a swab for sword, The skipper's Sunday hat for crown. But when the purser asked his fare, And only got an icy look. For satisfaction, then and there. We brought our passenger to book." Our Christmas Passenger written and drawn by Cyrus Cuneo.

Originally appeared in *The London News*, 1902

But what about the first voyages, when explorers met Arctic natives for the first time? There's only one case worth noting. Willem Barentz, of Barents Sea fame, met with Eskimos of northern Russia in the 1590s while looking for the Northeast Passage to the Spice Islands. This encounter was illustrated in the aforementioned book called *Petits Voyages*, a popular collection of de Bry engravings. The drawings

showed Barentz gesturing to Eskimos who, in the background, were busy hunting with bows and arrows or were reindeer sledding. Included in the far background was a snowman.

But the 1600 de Bry engravings were based on the illustrations and observations from a 1599 book by one of the twelve survivors onboard Willem Barentz's third voyage, Gerrit de Veer, whose journal was published when he made it back to the Netherlands. Although it was the engravers' job to convey information about the native way of life through details in the customs, costumes, and weapons, they often didn't know the world outside of their area. Illustrators thus relied on their biased imaginations and artistic egos, similar to the illuminators of the day at the height of Mannerism, a style that embellishes and exaggerates through use of color, scale, and perspective. With limited information, swayed by myths, and letting decorative urge overwhelm their historical integrity, the details were misconstrued. Gerrit de Veer never mentions snowmen in his very meticulous diary, where he even details the crew playing *colfe,* an early version of golf, on the ice. The drawings in his earlier book show groups of bizarre, armless figures of unknown material surrounded by what looks like chicken bones. Further examination of the surviving diary of Gerrit de Veer's sheds light on the mystery:

. . . they [the crew] found some four hundred crude statues of deities. [Famous traveler and historian] Van Linschoten named this place Afgodenhoek [Cape of Idols], the idols were made of roygh [sic] wood and placed slantingly against a support with their faces directed to the East. They represented figures of men, women and children. Some statues had more than four faces as if they depicted whole families. The soil around was littered with the offerings of reindeer antlers. [It was] supposed that the idols served for an ancient funerary tradition of heathen Lapps and Finns.

Russians first spotted these idols in 1556, and that same year, so did English explorer Stephen Burough during *his* failed attempt to the Far East. He called the Samoyed idols "the worst and the most unartificial worke [sic] he ever saw—completely devoid of artistry."

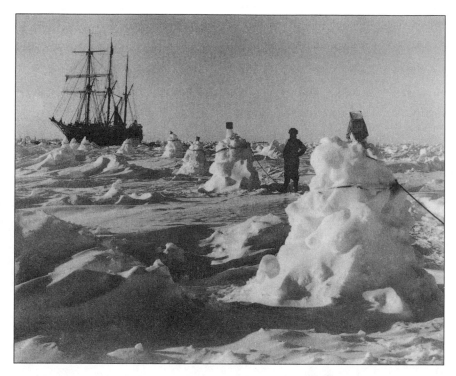

No, not snowmen but markers made by Ernest Shackleton's crew to serve as guidance during blizzards when their ship the Endurance *was trapped in ice in Weddell Sea, Antarctica, in 1915.*

Courtesy of The Royal Geographical Society

Although it remains uncertain whether or not people of the Laplands made snowmen in the sixteenth century, we know the Russians did. In the 1580s, Tsarevich Dimitry, the son of Ivan the Terrible, ordered his friends to build snowmen of his brother, Tsar Feodor, and Boris Godunov, a relative next to the Russian throne after Feodor. When finished, Dimitry demonstrated what he would do if *he* were tsar by stabbing the snowmen with a sword and cutting off their heads. Dimitry would never fulfill his dream, mysteriously dying of stab wounds at age nine.

The assumption that Eskimos would have been the first to start making snowmen ignores the basic laws of good snowman making. To pack snow, the humidity needs to be above 20 percent and the temperature above ten degrees. This is why it's actually easier to make a snowman in South Dakota than in an

Arctic region. Except for a few brief weeks in May and June, the snow in the Arctic is "bad" snow—too cold and dry to build igloos or even to make snowballs.

Although due to the uncooperative climate and maybe partly to do with their ambivalence toward mass media, the snowman was simply never a big part of Eskimo culture. There's but one minor snowman in Eskimo lore, a foul-tempered monster over three igloos high with a hot head. More could be said, but what would be the point? After all, there is no origin to the tale, and less than eight people seem to be aware of the legend.

As the search for the first snowman continues, we need to look toward civilizations thirsty for mass media and the center stage, the usual venue for snowmen. In the early sixteenth century, that means the glamour and pageantry (if you look past the famine, plague, and filth) of central medieval Europe.

Belgian Expressionism:
The Miracle of 1511

It is not the first time that great artists deign to sculpt this Carrara marble that descends from the sky onto the earth in sparkling powder.

—Théophile Gautier, *The Travels of Théophile Gautier*

I t took him over thirty-five months, but Michelangelo finally finished his seventeen-foot-high marble adolescent named *David*. Yes, it would become the world's most famous statue, a monument to civic courage and male beauty. But seven years later, something immensely more momentous occurred in the world of sculpture: A bunch of Belgians made a town full of snowmen.

Not only did the snowman exist in the Middle Ages, he flourished. At a time when stilts and puppet shows passed for entertainment, the public was starved for the next "big thing." With plenty of famine, plague, and sickness abounding, winter festivals and other government-endorsed morale boosters provided relief to the starving masses who were either feeding on grass or dropping dead. The thinking was to have the public blow off steam for a week or two and

allow erotic dancing, excessive drinking, and political jokes, all under government supervision. During one brutal winter, the city of Brussels covered the entire city with snowmen, a spectacle they called the Miracle of 1511.

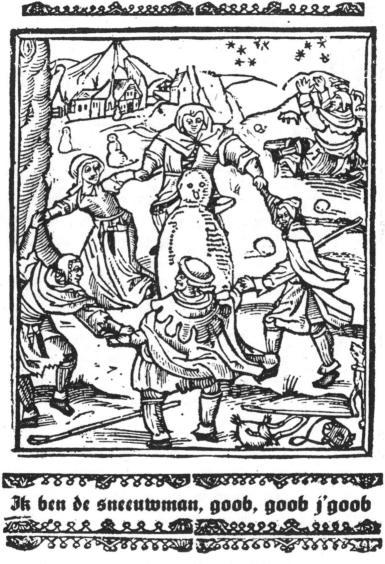

The Winter Festival of 1511 might have been reported by a chronicle like this.

© 2007 Bob Eckstein

For six straight weeks, beginning January 1, the temperatures stayed below freezing and these snow sculptures represented the public's fears and frustrations during what was called "the Winter of Death." It was a much needed distraction from the problems of class strife, low self-esteem, and, of course, the Guelders. (The Guelders were from Gelderland, once a part of the Low Countries in the Netherlands, and a group that enjoyed attacking Brussels.)

From the colorful surviving accounts, we know that these were not your run-of-the-mill snowmen. Every corner of Brussels was occupied with snowmen and snow women pantomiming the local news or classical folklore: snow biblical figures, snow sea knights, snow unicorns, snow wildmen, snow mermaids, and snow village idiots. Snowmen were juxtaposed with neighboring snowmen to create clever interplay and contrast. Many snowmen were based on the icons of the calendar, like Janus (January) and Pluto (February) or the signs of the Zodiac. There was a snow scene of Christ with the Woman of Samaria. A preaching friar with a dripping nose. A tooth puller. The "Man in the Moon." Roland blowing his horn. Cupid with a drawn bow atop a pillar. Saint George rescuing the princess from a dragon. Adam and Eve.

A Hercules stood outside the home of Philip of Burgundy, the bastard son of Philip the Good and commander-in-chief of the Netherlands. The miraculously beautiful and perfect proportions suggest that Philip was helped by the court painter Jan Gossaert van Mabuse, a leader in Italian architecture and Renaissance art who had just rendered several nude paintings of Hercules to quench Philip's fetish of the Greek hero. Everyone, even great noblemen, went outside to make quality snowmen, not just trained artists. And according to one account, everyone was doing a splendid job.

There were fifty elaborately executed scenes with a total population of 110 snowmen. The 1511 winter festival displayed politically charged and sexually obscene snow scenes in the streets for all to see—an early form of visual satire and commentary.

Current events, complaints, local problems—if it was a nuisance, it was sculpted. Snow gentlemen gambled near the *Houtmarkt* (the wood market).

Nearby, a fountain boy, who would go on to become the symbol of the city of Brussels, urinated onto a greedy drunk. A snow cow fertilized the ground. More than half the scenes were sexual or scatological in nature. Numerous snowmen were sculpted in erotic embrace. The preoccupation with sex was the medieval public's way of dealing with uncontrollable urges, and the town was fascinated by the snow porn they created. While they handled death with humor, the public could neither understand nor get its hands around sex. As is always the case, any advancement in society is quickly exploited for its pornographic applications—the invention of reading glasses and the printing press created a boom in pornography for a generation of previously illiterate, nearsighted Europeans. This newfound interest in smut festered, and what little porn was available in Belgium at the time had stirred things in the nether regions. A snow man and snow woman made love in front of the town fountain where the town fool was visibly excited. In the red-light district of Brussels, a hooker with carefully sculpted snow breasts and lower extremities attracted every passerby. In another scene, a snow nun seduced a man with her *lollepot*—a play-on-words for her "foot warmer." The Miracle of 1511 offered the townspeople an open forum to create erotic snowmen, a free pass to act impulsively on their horniness. This was their Woodstock.

Politically, the role of the snowman was never more integral to Brussels's community. The display of frozen politicians was the town's de facto op-ed page. Townspeople depicted the most feared characters, like the devil or enemy ruler, defecating. In one snow scene, a drunkard drowned in his own excrement. One group of snowmen, looking very much like those from a rival castle of Poederijen, show their leader wincing as his aide goes to the bathroom. Making the devil as a snowman helped the public laugh off this anxiety. A sculpture of the king of Friesland (Freeze Land) represented Satan, who was responsible for winter and blamed for deep frosts and the serious annual threat it brought to everyone's health and earnings.

Art historians, and historians of all disciplines, for that matter, have traditionally ignored the event of 1511 because, besides the artwork's transience, it was considered low art; the snow men and snow women were embarrassing

examples of the public's taste for explicit sex and an exorbitant amount of excrement. Four hundred and sixty-three years would pass before the public would see an anatomically correct snowman (in Woody Allen's *Radio Days*). But this was the norm for 1511. What we today would call toilet humor is what even bored academics found entertaining five hundred years ago. From wandering scholars to French fabliaux and courtly circles, burping, farting, and spitting ridiculed the opposing class and captured the public's imagination. The defecating, drunk snowman with his snow cow was meant to mock the despised rural life and was a big laugh-getter.

History has long since forgotten the Brussels snowmen of the Miracle of 1511 along with the ballad that describes the event by Dutch poet Jan Smeken: *"Dwonder van claren ijse en snee: een verloren en teruggevonden gedicht"* ("The Miracle of Real or Imaginary Ice and Snow: A Lost and Then Refound Poem"). While a shorter title could've helped, it was the ballad's status as "low art" that has left it neglected all these centuries. Despite a reprint published in 1946, literary historians still considered it a product of the artisan class, both amateur in style and written in a vulgar, rhetorician tongue instead of in Latin or French.

How do we know that the snow festival wasn't Jan's imagination? There are short accounts in diaries that confirm the Miracle of 1511 ("Many beautiful, splendid and surprising images of snow, placed all over town."). These accounts also support the claims of the snow figures being both politically and sexually active. We also know that Jan Smeken was the official city poet who reported, unveiled, and enhanced the snowmen's double meanings, animating the town's snowmen by ascribing them with properties of flesh and blood. Throughout the poem, his words cleverly maneuvered around direct descriptions of genitalia and graphic sex:

In the Rosendal a wonder was to be seen: a huge plump woman, completely naked, her buttocks were like a barrel, her breasts were finely formed, a dog was ensconced between her legs; her pudendum was covered by a rose; the 'coffer' beneath the rose, once you taste it, causes many a man to lose his silver-plate.

Jan Smeken also tells us that a virgin of snow with a unicorn in her lap graced the front of the ducal palace at Coudenberg in north Brussels. Although the unicorn is the traditional element of religious high art symbolizing Christ, the snow sculpture's location in the front yard of the home of the absentee duke Charles V suggested otherwise—this was a political cartoon about Charles refusing to live in his palace and his insistence upon living instead with his aunt Margaret of Austria in Molines. Just as the Virgin protected the unicorn against enemies, Brussels hoped Charles would have done likewise. Brussels would eventually welcome him back with a festival in 1520, and all was forgiven.

The Miracle of 1511 was neither the first snow festival nor the first with snowmen. There was one of a smaller scale in 1481, and other nearby cities hosted similar events: Mechelen (1571), Rijssel (1600 and 1603), and Antwerp (throughout the seventeenth and eighteenth centuries). But the Miracle of 1511 was the festival to top all festivals. It literally changed the society of Brussels, by giving the public a voice, shifting the balance of power back to the public, and changing the class system within Brussels forever. This was the snowman's defining moment; it demonstrated what snowman making can be about. Snowmen provoked thought, anger, joy, and even forced people to reassess their existence, their plight, their place in the world. These snowmen were rock stars of their day. Sadly, this story ends as every snowman story does: A sudden thaw in the spring melted all the snowmen, and Brussels suffered devastating floods.

Meanwhile, the following year, Michelangelo pulled off a little thing called the Sistine Chapel. Blasphemous! How dare we lump Michelangelo in with the pedestrian activity of snowman making? Ahhh, but Michelangelo had already made a snowman earlier in his life. It didn't snow often in Florence, but there was a tradition among artists to populate the city with snowmen when it did. In 1494, after a heavy snowfall on January 20, Piero de'Medici, who had inherited control of Florence, commissioned the young sculptor to model a colossal snowman in the courtyard of his palace for part of the evening's winter festival.

Critics thought this was a real insult to the great artist (a prank by Piero, knowing the work would only melt away), but Michelangelo felt indebted to Piero's father, who was an old friend and loyal patron of his work. The critic Théophile Gautier, who wrote about Falguière's snowman in Paris back in 1870, compared the two snow statues using Michelangelo's snow figure in Florence: "It is not the first time that great artists deign to sculpt this Carrara marble that descends from the sky onto the earth in sparkling powder." The Miracle of 1511 proved that snowman making was not for just great artists but an art for and by the people.

Vetruvian Snowman.

Drawing by Bob Eckstein © 2007

EARLY CLASSISM *in* SNOW SCULPTURE:
POLITICALLY INCORRECT FUN

His eyes were two coals; his nose a potato. His arms were flung wide; in one of them he held a broom, in the other a newspaper. This Golem with his amazed eyes and idiotic grin amused us all for an afternoon.

—Michael Gold, from *Jews Without Money*, reporting on a snowman in
a vacant lot on the Lower East Side of Manhattan.

O ne of the hot button issues surrounding the Miracle of 1511 was classism and the exorcising of class prejudices through snowmen. Each social class (the elite, the middle class, the lower class) created its own brand of snowmen caricaturing their opponents and reflecting their ambitions and obsessions. The opinions among these social classes caused heated animosity when expressed through the snowmen. Offended parties acted out by beating up the snowmen hurtful to them. Chronicles of the day reported the violence: *"St. Joris lost his head, the farmer Bouwen Lanctant lost his 3 times, and even the clerk from*

the fish-stand couldn't escape." This was not random vandalism but rather a reflection of class tension and what the snowman in question represented. One farmer put a large rock in the head of a shepherd snowman he made, knowing that at night there would be those to take a club to it.

The Brussels authorities decided to take action, and posted flyers with measures threatening severe punishments for any person caught damaging a snowman: *"The noble men from the city of Brussels proclaim that nobody, during day or night, could break any personage into pieces."* Yet, while city magistrates were involved in the policing of the snowman jackers, snowman makers could still choose subjects of their own free will and exercise free speech.

The public didn't always enjoy this freedom. Derogatory and misconstrued snowmen were such a problem in the fifteenth century that restrictions had to be placed on snowman making. Renegade snowmen appeared as all walks of life, and whether they mocked the working class or a member of the clergy, everyone was "thrown under the bus" or, in this case, the dung cart. People traveled from far away to take walking tours through the streets when snow fell, as it was popular a form of entertainment.

Snowmen were a huge phenomenon in the Middle Ages. As soon as kneadable snow arrived, towns filled with snowmen and snow sculptures comparable in quality and concept to stone and bronze sculpture counterparts. A pharmacist of a Florentine apothecary (a medieval drugstore), Lucas Landucci, wrote in his diary in 1510, *"A number of the most beautiful snow-lions were made in Florence . . . and many nude figures were made also by good masters."* A famous ballad written in 1461 by the great French poet François Villon asks, *"But where are the snow (figures) of yester-year?"* This was not referring to the prison Villon was writing from but to the snowmen of past winters, specifically, the gloriously creative explosions of Brussels (1457) and Arras, France (1434)—with their beautiful biblical representations, mythological stories, and medieval heroes.

It was in Arras that snowmen were born from an exceptionally harsh winter, when it snowed for three months and three weeks starting on November 30, 1434.

Reprinted by permission from Kyoto University Library

The Arrageois handled this by laughing in winter's face and throwing together an unplanned fête with death as the party theme. The danse macabre or "dance of death," of course, occupied all facets of life. "Victory" over death took place at funerals for those still living—with celebrations over the graves of the dead. Hookers preyed on widows in cemeteries. Fornicators and adulterers trysted among the graves. It got so bad that a papal official threatened excommunication to those "who danced, fought, bowled, played dice or other unseemly games or commit other unseemly acts" in cemeteries. If you were looking for a fête or danse macabre to crash in the fifteenth century, the northwest corner of France was the place to look.

In the past, winter fêtes would send the dangers of frost packing through dance, fire, and all-you-can-eat buffets, but the city of Arras was ill-equipped for this particularly dangerous season, so the festival was taken to another level. Historians establish that in 1434, the town of Arras produced spectacular snowmen. Although smaller in scale to the snowmen of the Miracle of 1511, they combined pop reference with learned culture, producing a sophisticated collection through the medium of snow. The pop culture references used (like the Seven

Sleeping Men of Ephesus) are so far removed from our idea of satire, it would be impossible for us to absorb without it being painfully dull at best. Yet, it was, for them, entertainment and folly, a spontaneous party for every reason that people have them today: to forget the pain; to dispel the fears of cold, death, court, church, and God knows what else.

Placed in the proximity of their targets, the snowmen were arrows of anticlericalism and impertinence toward the king. On the rue de Molinel, the great lord of Short-Life stood, made of snow, next to his tomb. A snow preacher named Brother Worthless held court at the corner of rue de Haizerrue representing hope, desire, and patience. Before the Inn of the Dragon stood the "Great Virgin" Joan of Arc, who passed through Arras three years earlier, in 1431, before she burned at the stake. At the Ernestal, a large woman named Pass-on-Your-Way stood. Other characters made in snow represented Renard the Fox, Samson the Strong, lepers, the emperor, the king, Death, and a workman—conveying equality in death. The Four Sons of Aimon steam bath was decorated with snowmen and snow women (as with other locations picked to make snowmen, this was a site of debauchery). Lavish (and very French), we know of the Arras snowmen because their craftsmanship and imaginative usage was newsworthy. If Brussels was the peak of snowman popularity, then Arras was the snowman's intellectual apex.

The "Little Ice Age" started around 1300, and snowfall became more common. Kings, queens, and dukes began to be demonized by depicting them in text as snow. Finding a mention of *anything* about snowman making before the Little Ice Age, which preceded a long stretch of warm weather, becomes increasingly difficult. Aside from the lack of snow, it wasn't until 1450 that newsletters began circulating in Europe, with books only block-printed (starting in 1423); most of the population was still illiterate. Instead, historians must rely on chronicle writers who covered important events—like the report of an extraordinary snow scene made in Doornik, Belgium, in 1422, of a lion in the role of a shepherd, watching over several sheep.

The earliest substantiated documentation of a snowman would be found in

the diary of a wine merchant named Bartolomeo del Corazza. In the winter of 1408, del Corazza describes an unforgettable snow figure just "two braccia in height" (two arms' length). Again, not to say it was the first actual snowman, but this was the first historical

snowman. It was made anonymously after four days of snow, a beautiful snow sculpture of Hercules in the middle of Piacca San Michele Berteldi in Florence—incidentally, the same city where Michelanglo's legendary snowman stood only some eighty-six years earlier.

This was not the first snowman. The snowman we're searching for is clumsy, poorly constructed and, at best, average looking. While the Hercules snowman of Arras may predate other claims to the birth of the snowman, this was not our man. Wherever and whoever made that first snowman, it wouldn't have been a masterpiece right out of the gates. Thanks to the major global change in climate, for every snowman preserved in any historical records, there must have been hundreds, if not thousands, of crappy unknown snowmen emerging throughout Europe and Asia.

The 1408 Hercules is a 1965 Aston Martin. We're looking for an Edsel. One with a bad muffler and no get-up-and-go.

CHAPTER SIXTEEN

ITALIAN SNOWBALLS *from*
the FIFTEENTH CENTURY:
THE TWO-BALL THEORY

Two balls are better than one.

—Anonymous

here there's smoke there's fire. It stands to reason that the search for snowmen has become a hunt for snowballs.

Italy, famous for spaghetti and snowballs, is the setting for an old tale found in *The Every-Day Book*. First published in 1825, this was a bizarre, confusing collection of facts and miscellany, dating back to the birth of Christ. The book functioned as a life manual, much like today's Farmer's Almanac. The old tale in question is that of a Saint Francis of Paula. This unfamiliar, yet colorful Italian saint presents a compelling case for ancient snowballs. In 1416, Francis was born with a swollen eye socket. His religious parents made a vow to send their son to a convent for one year, where Francis's bloated eye was immediately cured. As a preteen, Francis became a devout, and at age fourteen, he gave up everything to squat

Detail from Abel Grimmer's De Winter *(ca. 1600). Men put snowballs down women's blouses as an ice breaker and to desatanize. The Little Ice Age began around 1400, and by the 1560s the population was terrified the Earth would freeze over.*

inside a cave in a big rock off the coast of Calabria, the toe of Italy. By the time he was twenty, he had two other roommates. In short time, they would help him build a chapel.

Meanwhile, Saint Francis was performing miracles left and right. It was nothing for him to walk into a burning oven and hold burning coals in his hands. His résumé included predicting wars, bringing his dead nephew back to life, curing people of the plague, and making a sea voyage using his cloak (!) as a boat. He even had a companion "on board" with him, on his "cloak." The number of his followers eventually increased, and before you could say "Holy Saint Theodosia," his chapel had become quite the hangout—so much so, that in 1454, Saint Francis and his disciples had to build a large monastery. The house rules included no sex, no milk, and no eggs. It had the makings of the first reality show.

At some point, he had a nasty run-in with the devil. The story goes that, while Francis was praying, Satan asked for him by name three times. Feeling possessed by this shout-out, he decided the only sensible thing to do to rid himself of the devil would be to strip and begin whipping himself on the backside with a stick. "Crying while he did it, 'thus brother ass thou must beaten,' after which he ran into

the snow and made seven snowballs, intending to swallow them if the devil had not taken his leave." (*The Every-Day Book*)

Eating snowballs to ward off Satan would explain some of the peculiar snow activity pervasive in some later paintings. In Pieter Brueghel II's painting *Le Dénombrement De Bethéem* (1610), snowballs are seen being carted away and an angry mob force-feeds snowballs to a woman who could pass for a witch (not to be confused with the same painting made earlier by his dad, Pieter Brueghel the Elder, in which the snowballs are just thrown, not force-fed.). In *De Winter*, painted by Abel Grimmer around the same time, a man puts a snowball down a woman's blouse—no, not meant as an icebreaker, but to fend off the devil.

Why the public would embrace this notion is made more clear in Pieter Huys's *Le Jugement Dernier* (1554), a massive, ambitious oil painting on display in the Royal Museum of Belgium, in Brussels. The artwork depicts judgment day: a fiery hell vividly illustrated in the foreground, with scorched scenes of grotesque images and bodily functions. Heaven is in the background and is represented as a kind of cool, enormous igloo. Fire, bad; snow, good.

No one will ever find snowmen in any oil painting that is dated before 1420. First of all, artists avoided painting them in their winterscapes. The only legitimate explanation given (by art historians) is that snowmen are "visually difficult to depict" and are poor subjects since they're always melting. Of the 15,000 winterscapes from pre-1774 classified in The Hague, the most comprehensive catalog of art in the world, only a couple of them reveal a snowman. But the biggest reason there are no snowmen in oil paintings before 1420 is because there *were* no oil paintings before 1420. Before that, aside from illuminated manuscripts, artists worked with tempera (which was fragile) on wood or frescos (more fragile) on walls, a very restrictive method that forced artists to paint watercolor as fast as possible directly on the wet plaster. (The earliest surviving woodcut is dated 1418.) The nature of these media and their very poor survival rate also attest to the astronomical odds of finding a painted snowman.

The earliest visual evidence of a snowball can be found in an old fresco in

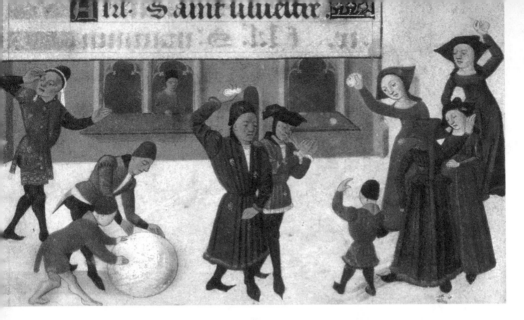

From December *(ca. 1460s), a winter scene created for the book of hours for the duchess of Burgundy, a father and son making an enormous snowball. This can mean only one thing—a 12-foot high snowman!*

Réunion des Musées Nationaux / Art Resource, NY

Trento in an ancient Italian castle called Castillo del Buonconsiglio. The large, peeling fresco is *January* of the common "cycle of the months" motif and was made in 1403. It illustrates a snowball fight in the foreground between two aristocratic groups: theorists and experimentalists; it's not clear who is winning. The background elements are chock full of symbolism. Ivory towers stand for the new mathematics. A bridge connects the castle to the "outside world." There are hunters with dogs—the one dog heading toward a bush where a badger is hiding signifies a graduate student solving a hard problem. All of this takes place in a snow-covered landscape, the first large representation of this kind in the history of Western painting. Much of this mural has flaked off the wall, but it is still one of the most beautiful paintings one will ever see.

While skeptics may question how any of this connects to snowmen, we all know every snowman starts with the snowball. Snowballs are clues, remote pieces of physical evidence. The snowman came about when somebody, after making a snowball, decided that two balls are better than one, and then, in a stroke of genius, placed one ball on top of another. There's a boy on the left side of Hendrick van Avercamp's *Winter Scene with Skaters Near a Castle* (1608) creating a large snowball.

But it would be presumptuous to assume this youngster has the imagination and/or desire to make that great bridge and place a second ball on top. In Chantilly, France (in the Musée Condé), there's a fifteenth-century miniature in which, after close inspection, a Frenchman rolling an enormous snowball can be spotted. From the scale, this snowball is a good three or four feet in diameter—clearly too large to throw at anyone. We'll never know what he had planned for his sphere: to continue to enlarge his big ball until he grew bored, or, we could dream and conclude he has just completed the lower extremities of an upstanding snowman.

One culture that fully realized the exuberance of putting one thing on top of another was the Japanese. Theirs is a world where a snowman has but two balls. How long they have been doing this is unknown, but man has always had the propensity for putting one thing on top of another—a primal instinct enjoyed since the dawn of time. Prehistoric sculptures found in Cypriote tombs of the ninth century B.C. and earlier used what archaeologists call the "snowman" technique to make figures out of clay by stacking forms upward—the same way we make snowmen.

Snowballs became illegal in Amsterdam in 1454.

Drawing by Bob Eckstein © 2007

CHAPTER SEVENTEEN

The FIRST SNOWMAN

Outside, in the dark, a wobbly patch of life upon the blue snow,
the deer perhaps browsed, her soft blob of a nose rapturously sunk
in the chilly winter greenery, her modest brain-stem steeped in
some dream of a Cockaigne for herbivores.

—John Updike, *Toward the End of Time*

I n 1492, Christopher Columbus packed his things and sailed, not in search of New York City or the sunny Caribbean, but Cockaigne, a country tucked away in some remote corner of the globe, an idyllic land, devoid of any of the world's problems. Over the years, Columbus became more determined in finding this earthly nirvana, and on his third voyage he discovered the Orinoco River, which he called one of the four rivers of paradise. Moreover, he concluded in a letter from Hispaniola, in 1498, that the world was not so much round as pear shaped, and a lot like a woman's breast, with the nipple as the newly discovered paradise. Medieval explorers all went in search of this paradise—everyone wanted to spend time in this spring break of the Middle Ages. It is here that we find the first snowman, the key to understanding the Miracle of 1511, and many of the snowmen of its time.

Everyone living in the Middle Ages had heard of Cockaigne at one time or another. Initially, it was a real place. It wasn't until much later that it became clear that nobody knew how to get there. Like Santa Claus and the Easter Bunny, people stopped believing in the place, yet stories about it continued to circulate throughout Europe for centuries. Spread by legend, art, and oral history, this imaginary land became the number-one tourist destination. This gratuitous paradise quelled the anxieties of an uncertain afterlife. To most, heaven was going to be a tough club to crack and many stopped banking on it after carrying on pretty disgracefully down on earth, so it seemed best to create a plan B.

Cockaigne is mentioned in the Holy Koran, and Professor Herman Pleij of the University of Amsterdam believes the rooster (or cock) guarding the Islamic heaven is the origin of the word *cockaigne* (pronounced like cocaine, but like cob). It has no connection to the drug but a remarkable coincidence. Europe's food shortage forced people to eat hallucinatory mushrooms, grasses, and poppies, which in turn led to masses getting stoned and dreaming of this fantasy land. For a long time, and against their better judgment, people tried to ration their flour by diluting it with sand, straw, grass, and even pig manure. Sometimes dinner even meant half-decayed, diseased animals—dogs, cats, donkeys, horses, and wolves as well as frogs and snakes. The French version of the word *cocaigne* translates to "land of plenty," ultimately deriving from the word "cake." Cockaigne provided hope and an imaginary escape from the *Fear*

This mythic land continues in various forms. Burl Ives, the most famous snowman ever, sang about Cockaigne in "Big Rock Candy Mountain," the theme song for the movie O Brother, Where Art Thou?

Courtesy of Rick Goldschmidt Archives (rankinbass.com)

Factor diet. People imagined the Cockaigne menu as full of delectable meats such as hare, deer, and wild boar, all which let themselves be caught. Grilled fish leaped out of rivers of wine onto your plate. Roast geese waddled down streets paved in pastry, just begging to be eaten. Flying pigs and buttered birds fell from the sky like rain, directly into people's mouths. People lived in edible houses made of pancake roofs and walls made of sausages.

In Cockaigne, work was forbidden, sex was free, weather adjustable, and your body could be altered on a whim (almost like today's unemployment benefits, all-you-can-eat buffets, climate-controlled homes, promiscuous sex, and plastic surgery).

It's in this topsy-turvy world that we find the first snowman ever in art of any form. Painted in the margins of a beautiful illuminated manuscript (currently in the Royal Library, in The Hague), which dates around 1380, is a snowman— wearing only a strange hat and a look of concern while his butt burns from a log fire under his stool. The melting snowman is created in the familiar method we're accustomed to seeing today: a modern snowman with one snowball stacked on top of another. Medieval snowmen had always been sculpted pieces of art, and without the snowman marginalia, it was uncertain whether the snowball method was even known at the time. Centuries would pass before anything similar would be seen again in any surviving books or art.

The text on the page is a sober, mournful psalm detailing the crucifixion of Jesus Christ: "Lord, you gave up the ghost shortly after uttering the words, 'It is finished.'" Next to this line is the snowman with his back to us. The snowman is not so much an analogy for death as it an extreme example of using humor to deal with pain. The hat tells us this is a Jewish snowman. Artists painted unusual hats on Jews to brand them as outcasts. Fools and court jesters wore hats while Christians removed their hats in front of the altar. While Cain is depicted in dozens of paintings in a variety of hat designs, the intention behind the use of a hat is to label the murderer Cain a Jew, while the hatless Abel is usually haloed. Paintings of the Crucifixion scenes often show those turning away from Christ and persecutors wearing bizarre hats.

The first recorded snowman ever. From Book of Hours, *Ms KA36, fol. 78 verso, Brussels, circa 1380.*

It is truly unfortunate that the oldest visual evidence of a snowman is anti-Semitic. The Cockaigne rationale for the melting Jewish snowman is twofold: (1) the ironic polarity of the light-hearted activity of snowmen making with the fact

it illustrates a passage about Jesus dying on the cross; and (2) it's the opposite of Christianity in the eyes of that unknown artist with the love of Christ playing off the "hatred" of Jews. Dying Europeans in the fourteenth century, needing to know why they were afflicted by the plague, sought out a scapegoat. Common people started a rumor that Jews of northern Spain and southern France were poisoning the Christian wells and spreading the plague. Pope Clement VI and recognized leaders tried to discredit the charge, calling the accusation "unthinkable," but by 1348, Jews were blamed for the disease's spread.

To so spectacularly and audaciously insult two religions at the same time is not easy—but this is where we find the bizarre, unimaginable beginning for the snowman. Today's snowman, the safe, nondenominational choice for the holidays, has come a long way.

The ICE AGE: WHO CAME FIRST, *the* CAVEMAN *or the* SNOWMAN?

A snowman depends on snow for its own existence—it can not exist unless snow exists. So, the snowman exists contingently. It has contingent existence.

—*Science Without Bounds:*
A Synthesis of Science, Religion and Mysticism, Art D'Adamo

I bet when Neanderthal kids would make a snowman, someone would always end up saying, 'Don't forget the thick, heavy brows.' Then they would get all embarrassed because they remembered they had the big husky brows too, and they'd get mad and eat the snowman.

—*Deep Thoughts* by Jack Handey,
Saturday Night Live

L et's rephrase that question (because, to start with, there is no evidence Pleistocene people *commonly* lived in caves): Did *prehistoric* man make snowmen?

With no forensic evidence to work with—coal that may or may not have been an eye for a prehistoric snowman, no fossilized top hat or petrified carrot—it seems an impossible task. But one carrot does not a snowman make, and absence of presence

isn't presence of absence. Some of the world's leading experts in anthropology have affirmed that early man probably created snowmen. Snow has been one of man's first available, pliable materials, as paleoanthropologist Professor Emeritus Dale Guthrie of the University of Alaska points out: ". . . snow images probably started early in prehistory as they are so easy to produce." Indeed, of the thousands of day-to-day activities in our lives, making snowmen may very well be among the handful we still share with our ancestors.

Noted art theorist Matt Gatton states, "Once the art idea was unleashed— which may have occurred in different ways, in different places, at different times, to different peoples—it is probable that representations were made in a multitude of available materials including durable materials like stone and bone (which form the archeological record), but also impermanent materials such as wood, leather, bark, and yes, snow."

Primal art has reached us under highly distorted circumstances and is completely unrepresentative of what originally existed. Artwork made of stone with extreme conditions of preservation (the frozen, the arid, or the protected) is only the tip of the iceberg, and yet the amount of prehistoric art that has survived

A stone idol or stone snowman?
ca. 3000 – 1500 B.C.

is in the tens of millions. Prehistoric man was an experimental being and wildly prolific during what was called the "Creative Explosion," in the Upper Paleolithic period (circa 40,000–10,000 years ago, which coincided with the Ice Age). Art made from wood, feathers, hides, mud, sand, and, of course, snow was up against impossible odds of ever surviving 5,000-plus years. Any art that has survived has done so purely on chance. Destruction by animals, erosion, farming, pollution, vandalism, and even types of stones that flake means any art we see today had to be very lucky. The snowman was not so lucky.

It's assumed that primitive snowmen would have served some kind of utilitarian purpose, whether they were worshipped as snow gods or used as scarecrows to ward off undomesticated animals. Perhaps they were part of some reproductive ritual or were a visual aid to teach cave tots biology. Maybe prehistoric snowmen were utilized as a sort of tombstone made in the likeness of the unfortunate soul buried below, or placed inside the snowman (possibly the first cryogenic suspension), like the Egyptians with mummies. Many of the ancient clay anthropomorphic figurines that survived were made using what archaeologists call "the snowman technique": stacking rounded forms on top of one another. There's even some stone art that bears a striking resemblance to snowmen.

Throughout history, artists' renderings of themselves are seldom realistic and almost always are idealistic. Whether it's Michelangelo's impossibly perfect body of *David* or the *Venus of Willendorf*, man has, without fail, accentuated what physical attributes were sought after at that time. The 25,000-year-old *Venus of Willendorf*, at first glance, could be mistaken for a stone snowman. But its features of blubbery fatness and in-your-face fertility were attractive assets at that time in history, making Venus a top model in her day and in sharp contrast to today's top models who show no evidence of knowing how to find food. Ironically, it's exactly the former fat body type that matches the snowman's body shape. In other words, the snowman fits the Paleolithic man's perception of what is sexy and desirable.

This modern drawing of the Venus of Willendorf illustrates that the snowman look was once hot, give or take 25,000 years ago.

© 2007 Bob Eckstein

But not every figure was created to pray to, and not all art was made by Stone Age stoners hopped up on strange plants for some ceremony or "part of the hunt" in the depths of caves (again, just a small fraction of the

prehistoric portfolio). Not all artists had to be elder male shamans. Scientists are now recognizing our species as an art-making animal, meaning we were capable of other actions not immediately related to reproductive fitness. This includes playing. Much of Paleolithic art was executed quickly in a playful, half-assed manner: having fun, goofing off . . . making snowmen? Perhaps.

New forensic technology used on fossil handprints is now telling us all ages and both sexes created art, that Paleolithic children made and played with art—part of groundbreaking evidence showing the importance of play in the development of art and art for art's sake. In other words, prehistoric snowmen could have existed solely because they were fun to make or to simply dress up the yard. The idea that children created prehistoric art is exciting and lends itself to building a case for the early snowman. Because of the way our brains develop, children have always been more likely to build snowmen as they are more likely to recognize familiar images made of other materials. Knowing that, coupled with the fact that most of the population was under twenty years old (you were lucky if you made it to thirty), transforming nature into culture seems quite . . . natural. Playfulness plays an important function in civilization. It was a couple of kids playing in their garage who stumbled onto the most significant invention of our lifetime: the computer. Everything's connected.

The connection between the "caveman" and the snowman is too strong. Man has always created likenesses of himself. Why wouldn't we believe snowmen were made back then—where's the evidence to the contrary? If man could build Stonehenge and the Great Pyramids, then building a snowman should have been child's play.

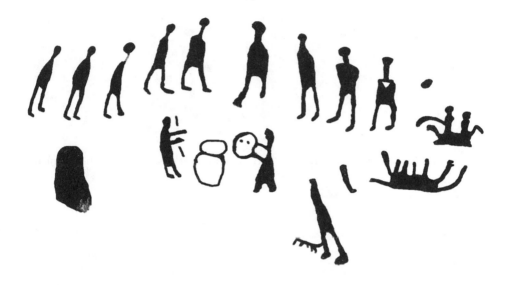

We can only speculate what hunters and gatherers did in their leisure. While man has yet to find a photograph or petroglyph depicting a snowman (like the rendering above) there is always hope with new cave art continuously being discovered. Drawing by Bob Eckstein © 2007

CONCLUSION

The
COMPLETE
MELTDOWN

Time and tide melts the snowman.

—Doctor Who

Here comes the sun. It's all right.

—George Harrison

There is a northern Japanese village that gets clobbered with over ten feet of snow a year—and its residents, to keep sane, build thousands of snowmen to lift their spirits. Rising over 2,000 feet above sea level, the village of Shiramine is now part of Hakusan but for years was home to just 1,200 residents. During Yukidaruma Week, the town's population would increase to 3,200 when the snowmen outnumbered their creators. Called *yukidarumas*, these snowmen are designed with a cavity in their stomachs to house lit candles—by nine in the evening, the whole town would be aglow with illuminated

Rare netsuke from the 1900s "Boy & Daruma Snowman" by Masahiro. Netsukes are small sculptures which serve as toggles on Japanese robes.

Courtesy of Dmitry Levit Asian Art

snowmen for visitors to enjoy. *Yukidarumas* (or snow darumas) were inspired by the good luck toy, the dharma, which, like snowmen, have no legs and, like Japanese snowmen, are made with only two balls stacked on top of each other. The dharma toy has earned a prominent place in Japan's cultural heritage and typifies his elevated position: No matter how you push the toy, it bounces back into the upright position like a weeble. The dharma comes from Bodhidharma, a sixth-century Indian Buddhist who founded Zen Buddhism. According to legend, Bodhidharma sat immobile, meditating for nine straight years, resulting in such

❄ WHAT'S IN THE SNOWMAN'S FUTURE?

After much pondering, I can think of but one last horizon, one last virgin frontier of pop culture for the snowman to conquer. I'm speaking, of course, of the snowman becoming a brand name for a professional sports team. (No, the Extreme Snowmen of the popular Internet X-BALL league doesn't count because (1) the team never really existed; and (2) there's no such sport as X-Ball.)

Snowmen have already been attending games. On December 7, 2003, in Giants Stadium, during an embarrassing loss to the Redskins (and the Giants' fifth in a row), snowmen outnumbered the fans. But I mean on the field. Somehow this has eluded the snowman's impressive resume. Imagine the Philadelphia Frosties and 300-pound linemen dressed as snowmen running out of the tunnel onto the field, taking on the likes of the Vikings or the Bears. Or a hockey team: the Colorado Avalanche versus the Seattle Snowmen.

Of course there's a perfectly logical reason why this hasn't happened

severe pins and needles that he lost the use of his arms and legs. It was said he went on to spread his teachings, rolling himself all the way from India to Japan.

Although I was unable to find out the exact history of the *yukidharma* or the dawn of Japan's first snowmen, I delved into the far-reaching history of the dharma, sometimes called the Buddha-Dharma. I'm aware of the cryptic references to holy snowmen made in ancient times (a "snow-image Buddha" is mentioned in the first scroll of the Lalitavistara, Taisho Canon translated A.D. 308), and with the help of leading Tibetan historians, I hoped to substantiate the claim that Buddhists made snowmen in seventh century North China.

Both *The Fengdao kejie* and the *I Ching* (the oldest of the Chinese texts) provide their followers with guidelines for conduct and rules of worship—including how holy images may be reproduced. The *Fengdao kejie* (also called *The Daoist Monastic Manual*) contains an actual list of "ways to fashion the perfected countenances,"

yet, and it's no fault of the snowman's. Had there been any northern cities or states in the major sports that began with an S or an F—to roll off the tongue with the names Snowmen or Frosties—surely this would have been a done deal. (Seattle, you have has no excuse. The Seahawks?) That's why I send out this plea to the good people of Spokane, Fairbanks, and Fort Salonga: Get your acts together and outfit a sports team. Stop building snowmen; start building a stadium! It's up to you. I've extended a tremendous hand by generously providing the following professionally designed logos for you to choose from or to use as a mental springboard. With the aid of my progressive suggestions, I believe the dream is within reach.

Spokane Snowmen

PHILADELPHIA FROSTIES

Schuylkill Chill

Scranton Snowball Heads

Artwork © 2007 by Bob Eckstein

with the last method being, *"18. Printed on paper . . . carved in ivory . . . shaped in piled-up snow . . ."* This was not only a blessing but encouragement to make iconic snowmen. *"If one can make any of these images with concentrated thought and a full heart, one will gain good fortune without measure."* (circa A.D. 610–640)

It was T. H. Barrett, professor of East Asian History at the University of London, who shared this information with me when I appealed to him as a leading authority on the subject of fifth- and sixth-century Buddhism to help clear up this muddle: "Both *I Ching* and the Taoist writer of the *Fengdao kejie* want us to know that it is okay to build holy images out of snow," he explained. "This does not exactly prove that anyone did so, but it would be slightly pointless to mention the fact if it were not considered at least conceivable by the author that someone would at least wish to do so. Maybe not everyone rushed out and did exactly what it said, but I would guess that at least some people did. I would therefore conclude that Taoists really did make images (sculptures) out of snow in the seventh century, and that after the *I Ching*'s return to China, Buddhists probably did so as well as a matter of competition."

That's not enough, as the professor points out, to go around saying there were snowmen in seventh-century Northern China—without a definitive source citing a snowman—but the awareness of snow sculpture that far back, in itself, corroborates the rumblings of earlier snowmen yet to be discovered. My hunt for snowmen in the Dark Ages of Asia will no doubt continue.

As thorough as my research has been, I have been unable to find that first snowman. To rub it in, the fossils of the prized "Iceman" were recently discovered in the Italian Alps in 1991: a fully clothed specimen of early man of great importance dating to 3300 B.C. But no relation to the snowman. Whenever and wherever that first snowman was made, he has long since melted and left us no remains. But we all melt. All through time, everybody—the famous, the forgotten, the rank and file—eventually fades away.

Probably the biggest threat to the snowman is not global warming, as one might expect, but the extinction of our innocence. Our vanishing youth and patience have more to do with the destiny of this wintry pastime than the consequences of automobile

emissions and excessive hairspray. Four out of every five kids suffer from attention deficit disorder, using their iPods to fill the insufferable endless minutes they have to wait for their Pizza-in-a-Cup to microwave. Not the ideal climate to get teenagers interested in building a snowman from scratch.

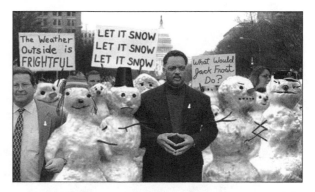

Nation's Snowmen March Against Global Warming as covered by The Onion during the hot spell of 2006

The Onion, copyright © 2006, www.theonion.com

"It is perhaps the saddest, most hopeless thing we can say about our culture that it is a culture of distraction," Professor Curtis White of Illinois State University states in his book, *The Middle Mind: Why Americans Don't Think for Themselves.*

The snowman is not an endangered species—yet. We have to just continue to make snowmen and to teach children that they don't have to spend a lot of money to have fun. Encourage them to be creative doing something tactile, something involving physical activity, something outside. Remember, once they put on mittens, they can no longer use a cell phone or a keyboard.

No kids? What's more romantic than a date to make a snowman? You're working together, it's playful, the setting is picturesque—all an excuse to come in afterward to warm up in front of a fireplace (plus, now you're equipped with an arsenal of snowman fun facts to fill the inevitable dead air). Furthermore, it's a cheap date.

So put down this book now, grab a kid or loved one, and go out and make a snowman.*

*If there's no snow outside yet, you could thank that damned global warming.

Miscellanea

Before the Massacre of 1690, Captain John SanderGlen sent scouts out daily to spy for unfriendly Indians and pleaded with Fort Schenectady to guard their gates. The Dutch villagers hated Glen, even threatening him, and he was not welcome in the village even though he owned a home there. Instead, Glen lived across the river in the town of Scotia. Historian Edwin G. Conde wrote in an unpublished manuscript, *"Capt. Glen tried to loosen the frozen (open) gates and . . . made snowmen on each side."* Did Conde "credit" Glen for the snowmen to put the blood on his hands, insinuating that Glen was mocking the town's delinquency? Perhaps, but Glen did try to save Schenectady before and *after* the massacre (plus, earlier accounts place Glen across the river).

According to the *Early History of Schenectady*, after a night of rum and dancing, the Indians awoke at daybreak and retrieved Captain Glen from his estate on the other side of the river. The French assured the captain they meant no harm and "had orders not to hurt a chicken of his." Why? Five years earlier, Indians had brought a French Jesuit priest from Canada to Glen's estate and asked that Glen lock him up until the next day, when they planned to torture and kill him. Glen pretended to fear the magical powers of the priest and told the Indians to lock the priest in his cellar. Glen gave them one of the two keys and said that he would have nothing else to do with the matter because he couldn't assure them the priest could not send his spirit through the keyhole. Early the next morning, Glen hid the priest in a cask in his carriage heading for Albany under the guise of sending his workers for salt. This rescue gratified the Canadian French and it was one of several occasions that Glen saved the lives of the French.

Now, as payback, Glen was brought back to the fort on the morning after the massacre and told that they would spare all of his kindred. Glen picked out as many prisoners from the crowd as possible, until the Indians caught on that everybody seemed to be related him. The attackers then torched the town, saving only six out of eighty homes—Glen's being one—and taking off with twenty-seven prisoners and fifty of the best horses.

My research included wild goose chases, and one was after a horse (of course, I thought I was chasing a snowman). You can search for a single word through millions of scanned publications and academic papers unearthing items that, before the digital age, would have taken a lifetime to find. The only problem is

that this also means endless amounts of leads with no way of knowing if they have any historical merit. A turn-of-the-century long shot named Snowman wasted many of my hours until I learned I was tracking down old racing forms. There was another horse named Snowman in the 1950s, a Cinderella story, of sorts, about an old gray horse bought for eighty dollars right off the truck bound for the dog food factory. As might be expected, Snowman went on to become a famous champion show jumper, inspiring his own fan club, making guest appearances on TV, and becoming the subject of two books.

The oldest book that was just about snowmen would be the *Collection des Desseins des Figures Colossales & des Groupes qui ont été faits de Neige*, which is French for *The Collection of the Designs of the Colossal Snow Figures, Faces, and Groups*. The book of twenty-four engravings documented a fund-raiser by the Antwerp Academy of Belgium in January 1772. Two dozen masterful snow sculptures were constructed in the streets and squares of Antwerp, most based on classical themes: Hercules, Neptune, and—the largest at forty feet—Bacchus. It was snowman making of the highest order as highbrow fine art.

Conversely, the TV special *Frosty* was drawn in Japan with the style of low-production Magic Marker. The producers of *Frosty the Snowman* wanted to emulate Paul Coker, Jr.'s greeting-card style—which the *Mad* magazine cartoonist had made famous at Hallmark. How great Frosty might have looked can be seen in the original drawing of Mr. Coker's, included earlier in this book. All of a sudden, Frosty really *does* come to life. But it's clearly not captured in the animation. This was just one problem with the lackluster TV special. Beyond his friendship with the little girl, he schlepped off up to the North Pole—where's this girl's parents?—and the been-there, done-that fear of melting, there is little character development for Frosty. At least in *Mr. Magoo's A Christmas Carol*, we really know by the end what makes Magoo tick.

But the biggest problem is the music, or rather the lack of it. While other Christmas specials have a full sound track of catchy tunes, Frosty had one song, repeated over and over. Jazz pianist Vince Guaraldi created a brilliant score for *A Charlie Brown Christmas*. The award-winning Grinch had hits about Whos. *Mister Magoo's A Christmas Carol* even had to cut a song when the artists ran out of time. Instead, the composers used "People" in their Broadway musical *Funny Girl* and it became Barbra Streisand's first hit. These other holiday offerings had raised the bar. They not only brought a new and distinctive look to the genre but included memorable performances and songs that still last the test of time, making them holiday staples.

While responsible for defining our first perception of the holidays, Currier & Ives managed to keep the snowman off their payroll—he was shut out of the more than 4,420 prints they created and sold into the millions. Even their artist known for his snowscapes, George "The Snowman" Durrie, refused to make a single snowman. Coincidentally, the pair of engravers sold their first print in 1856, the same year Larkin Mead commemorated his new drawing school by making the most important snowman in America.

Sculpting a snowman was just the beginning for Larkin Mead. When Lincoln was assassinated in 1865, Mead began campaigning to design the Lincoln Monument. There was an official contest in 1868 and with the help of the *New York Times*'s endorsement, Mead beat out thirty other artists and was awarded $70,000—the largest endowment received by an American sculptor at that time. Unfortunately, as one art historian put it, the Springfield, Illinois monument was "one of the slowest to be completed." Lincoln's secretary of state, William H. Seward, was to deliver the address at the dedication, but he died months before the ceremony. His replacements kept

dying off too. Unable to wait any longer, Lincoln's body was moved to the incomplete monument "without any ceremonials whatever" in September of 1871. Old acquaintances viewed the body to certify it was Lincoln before attendants placed him ten feet below the marble floor in a concrete vault. (A vault was needed. There was later an unsuccessful plot to kidnap Lincoln's body from the crypt.)

Finally, on October 15, 1874, a day many thought would never come, Mead finished the Lincoln Monument. The day began with a two-mile-long procession past a crowd of more than 20,000 to the rotunda. Mead's ten-foot statue of Lincoln stood above the entrance. In attendance was President Ulysses S. Grant and Todd Lincoln, the only Lincoln son of the four to outlive the ceremony's postponement. Mrs. Lincoln was absent, having previously visited Larkin Mead's studio in Florence to check on the progress of the memorial. Obviously, that was enough, emotionally.

As a reward for writing Abraham Lincoln's biography, William Dean Howells was given a job as an American consulate in Venice. He would later become "the Dean of American Letters" publishing his friends Mark Twain and Henry James while editor of *The Atlantic Monthly*. But at this stage of his life, he could not afford to go to America to visit his fiancée. No matter, Elinor Mead, like her brother Larkin, was assertive and worldly—both having grown up with religious fanaticism and sexual scandal. (Their father, Larkin, Sr., a noted lawyer, kept their uncle John Noyes out of jail for adultery. A leader of a utopian community, Noyes preached that every man is the husband of every woman, and every woman the wife of every man—a genius plan that backfired.) That said, the independent and notoriously chatty Elinor, with Larkin tagging along, took a long ship ride. When they arrived in Europe, Elinor married William, and Larkin went to Florence to study sculpture.

Larkin returned to Venice four years later and while walking in the piazza fell in love at first sight with a beautiful young Venetian. Too shy, he never approached her and he returned to Florence. But he never forgot the girl and with the help of the U.S. embassy, he found her when he returned to Venice. As soon as they met, she fell in love with him. Mariettda di Benvenuti and Larkin Mead sought a religious ceremony but were rejected because she was Roman Catholic and he Protestant. An appeal to the pope did not help. It also didn't help that the bride and groom could not speak to each other, since neither knew a word of the other's language. But it made for a marriage made in heaven for someone who grew up with a blabbermouth sister like Elinor (her spouse boosted "she could chat while a dentist worked on her teeth."). Larkin had found his angel, and in 1866 the muted couple married in a civil service.

Who was *not* connected to Larkin Mead? An obituary that ran on the cover of *The New York Times* for a colonel James Fisk came up during a snowman word search. The colonel was born and raised in West Brattleboro—Larkin Mead's hometown. As a matter of fact, it was Colonel Fisk's dad who owned the general store where nineteen-year-old Larkin worked as a clerk and was "discovered" as an artist. Two years prior to his famous Snow Angel, a customer admired a pig that Larkin had carved out of marble, and recommended that Larkin go to Brooklyn to study sculpture. Larkin took the advice to heart and left for New York City. Did the Colonel know Larkin?

The original hard copy of the January 27, 1884, newspaper, although barely legible, stated that Colonel James Fisk was a decorated officer, had acquired colossal wealth as a railroad tycoon, fell from grace through scandal and, finally, was shot dead by his business partner. His obit confessed, "The recent acts of Fisk require no extended mention. In fact, the less said the better for his reputation." The mystery was solved after reading the fine print regarding Fisk's childhood: *". . . his training as a magician, his natural tendency for the stage. His old experience as a showman made him hanker after places of amusement."* So, it was *not* his old experience as a *snow*man that had him hankering. The computers had erred: It was merely a bizarre coincidence that the two men had grown up on the same block over 150 years ago.

Speaking of strange obits, Saint Francis of Paula, famous for swallowing snowballs to exorcise the devil, died in 1508 at the ripe old age of ninety-two. But not one to ever pass up the chance to be dramatic, he was dug up later in 1562 by the Huguenots—a group of Swiss political radicals—who, for reasons that only make sense if you're in the Middle Ages, burned Saint Francis's bones with a wooden crucifix.

To play devil's advocate and explore an alternate explanation as to why a melting snowman would appear next to a passage about Jesus dying on the cross, we can expound on the theory that "snow" appears throughout literature to describe dying, as in the melting away of your possessions and earthly things. Middle Dutch had a word for dying, *dooien*, which literally meant "to thaw." Even Jan Smeken concluded in his poem about the Miracle of 1511, as the town of snowfolk melted away: *"God grant that we may die like this, And cause our sins to melt away."* We could conclude that the snowman in the manuscript illustrates a passage, as a literal interpretation of dying as melting. But, unfortunately, most signs point to the original interpretation: that our founding snowman's presence has more to do with prejudice and the shocking contrast of "true faith and heathen religion." Like it or not, this conclusion is based not on one person's opinion but the collective findings of experts and examples of similar marginalia work. The lighthearted figure we now associate with a snowman is truly a polar opposite from this intensely symbolic, early icon.

For thousands of years, Eskimos have made symbols out of stacked stones. Called *Inuksuits*, they are fascinating sculptures and, like so much early folk art, practical with multiple functions— direction pointers and messages for the next group passing by. Most of the time the piled-up stones resembled people. Eskimos erected them along the Caribou trail and stood alongside them to give caribou the impression of a larger crowd, funneling the rushing animals into pits for slaughter. Inuksuits have also been dressed up with caps and sweatshirts to advertise, à la snowmen, everything under the sun, from food, beer, to even what bank to use. But ironically, these anthropomorphic figures were seldom sculpted in snow.

It was wrongly assumed that Eskimos would have made snowmen dating back to Gerrit de Veer's misinterpreted diary in 1599. No European had ever wintered that far north before, and three hundred years would pass before explorers would make another serious attempt to reach the East Indies by way of the ruthless Arctic Ocean. Their last port of call was Novaya Zemlya—a place as unearthly as it sounds, hidden above Russia in the shadows of the North Pole. Barentz's third attempt proved fatal, and he died in the sea he had named after himself. Two shipmates were killed by polar bears. As one of the twelve survivors onboard, Gerrit de Veer had his journal published in French, Latin, Dutch, and Italian and revealed interesting facts as to how the crew of seventeen coped with waiting through the black winter of 1595 in hopes that the ice would

break up enough in the spring, as well as valuable information. (Today, de Veer is credited for the scientific discovery of the Novaya Zemlya Effect, the polar mirage where the sun appears above the horizon weeks ahead of schedule.)

De Veer's diary told of the time: *"[finally on] 15 of May it was faire weather . . . it was agreed that our men should go out to exercise the bodies with running, goeing [walking], playing at colfe and other exercises, thereby to stirre their ioynts [sic] and make them nimble."* "Other exercises" makes one wonder if that couldn't include snowman making. The crew enjoying *colfe* is a rare reference to an early version of golf, a Dutch sport where the object was to putt a stone or ball into a stake stuck in the ice. But who knows how much enjoyment they really experienced. The winter was unbearable, and they were forced to burn lamps from the fat of the "cruell [sic] bears." The cold stopped their clocks, froze their wine, and stiffened their bedsheets. Their books, flutes, and drums provided no comfort—as it's difficult performing in a power trio jazz band when it's 40 below.

Stephen Burough corroborated Gerrit de Veer's observations of the idols mistaken by engravers for snowmen. The sixteenth-century explorer called them "the worst and the most unartificial worke [sic] I ever saw—completely devoid of artistry." Made from old sticks, crudely shaped men, women, and children had human blood smeared around their eyes and mouths. Surrounding this horrifying scene were poles displaying the skulls of bears and deer. Burough's critical assessment stems partly from Europe's overblown fear of witchcraft at the time—nothing gave seamen the willies more than Satanism. The Lapp and Samoyed natives of the North were considered by Europeans to be skilled in the arts of black magic and were accused of cannibalism to boot. Fables had existed—thanks to the likes of poet/instigator Giles Fletcher, the Younger—about ghost ships and the natives' ability to control the winds. While sailors about that time started to doubt this shipping lore, they nevertheless feared these Samoyed burials. Dutch shore parties were physically shaken when they returned to their ship and required time to block out the possible repercussions from walking on those sacred grounds. The ships would return to their home in the Netherlands well stocked with stories of horror beyond the horizon.

I, too, returned home from the Netherlands teeming with amazing tales from afar. The nuts and bolts of my snowman hunting, as ridiculous as it sounds, was actually hitting the pavement looking for snowmen, traveling to libraries and institutes of foreign cities where historic snowmen once stood, and meeting face-to-face with historians. The most enlightening encounter was with Professor Herman Pleij at the University of Amsterdam. My three-week journey to reach Professor Pleij began by plane and then a trolley to the Brussels city museum, where old maps charted the snowmen made in 1511 that Professor Pleij wrote about in his book, *De sneeuwpoppen van 1511*. Days later, an express train took me to the Royal Library at The Hague, where I met with experts to discuss the particulars of the first printed snowman in that historic, illuminated manuscript from 1380. I was also curious about any other snowmen that may have existed in their art catalog—the Royal Library's collection of images is the world's largest, at 8 million. I focused on the approximately 15,000 woodcuts, drawings, etchings, and paintings created before 1750 that were categorized as winterscapes, examining each suspicious mound of snow with a magnifying glass.

After I accomplished that arduous task, I hitched a ride to Amsterdam from an old friend who also acted as my Dutch translator. Always looking for any snowman references, we spotted a very old mural on the outskirts of the city of explorer Willem Barentz. Once inside the city, I made my way to the university by foot. Our route took us past some of the city's most popular tourist attractions: a quick peek in "The World's Smallest Art Gallery" (the size of a closet),

a brisk walk through the red-light district and past its famed Banana Bar flanked by bikers offering coupons . . . and a hurried tour of Rembrandt's house, where the famous artist went bankrupt, only a snowball's throw from the center of the city.

Finally, I arrived for my long-awaited appointment with Professor Pleij. As the leading authority in medieval cultural studies and, more importantly, snowmen in the Middle Ages, our lengthy conversation regarding my fieldwork was invaluable. At the conclusion of our meeting the distinguished professor gave me his blessing and declared he was passing the torch of "snowman expert" on to me. My Dutch friend documented the moment and our good-bye handshake with photographs and asked if I remembered where we had passed the Banana Bar.

BIBLIOGRAPHY

Addams, Charles. *The World of Charles Addams.* New York: Alfred A. Knopf, 1991.

Alexander, Caroline. *The Endurance: Shackleton's Legendary Antarctic Expedition.* New York: Alfred A. Knopf, 1999.

Alperson, Philip. *The Philosophy of the Visual Arts.* New York: Oxford University Press, 1992.

Amendola, Joseph. *Ice Carving Made Easy.* New York: Van Nostrand Reinhold, 1994.

Anderes, Fred, and Ann Agranoff. *Ice Palaces.* New York: Abbeville Press/Cross River Press, 1983.

Annals of Brattleboro. Brattleboro, VT: E. L. Hildreth, 1922.

Andersen, Jens. *Hans Christian Andersen: A New Life.* New York: Overlook Press, 2005.

Arctic Miscellanies: A Souvenir of the Late Polar Search by the Officers and Seamen of the Expedition. London: Colburn, 1852.

Avery, Charles. *Florentine Renaissance Sculpture.* London: J. Murray, 1970.

Bahn, Paul G. *The Cambridge Illustrated History of Prehistoric Art.* Cambridge:

Cambridge University Press, 1998.

Bakish, David. *Jimmy Durante: His Show Business Career, with an Annotated Filmography and Discography.* Jefferson, NC: McFarland, 1995.

Barrett, T. H. *Bulletin of the School of Oriental and African Studies*, vol. 60.3, University of London (1997).

Bettley, James. *The Art of the Book: From Medieval Manuscript to Graphic Novel.* London: V & A Publications, 2001.

Birch, John. *The Story of the Schenectady Massacre.* Schenectady, NY: Schenectady County Historical Society.

Blankert, Albert, and others. *Frozen Silence.* Amsterdam: Waterman Gallery, 1982.

Boyarsky, P. V., and J. H. G. Gawronski. *Northbound with Barents: Russian–Dutch Integrated Archaeological Research on the Archipelago Novaya Zemlya.* Amsterdam: Uitgeverij jan Mets, 1995.

The Boy's Book of Sports: or Exercises and Pastimes of Youth. New Haven: Babcock, 1838.

Bradshaw, David, and Kevin J. H. Dettmar. *A Companion to Modernist Literature and Culture.* Malden, MA: Oxford University Press, 2006.

Brattleboro Reformer. Brattleboro, VT, 1908.

Brock, H. I. "American Life Pictorial in the Prints of Currier & Ives." *New York Times*, December 29, 1929.

Burke, James. *Connections.* Boston: Little, Brown, 1978.

Burman, Ruth. *Snowy the Traveling Snowman.* New York: Action Play-Book, 1944.

Cantor, Norman. *In the Wake of the Plague*. New York: Simon & Schuster, Free Press, 2001.

Carpenter, G. W. *An Account of the Burning of Schenectady*. ca. 1834.

Catoir, Barbara. *Miro on Mallorca*. Munich: Prestel, 1995.

Clausen, Søren, and Stig Thøgersen. *The Making of a Chinese City: History and Historiography in Harbin*. Armonk, NY: M. E. Sharp, 1995.

Clayson, Hollis. *Paris in Despair: Art and Everyday Life under Siege (1870-71)*. Chicago: University of Chicago Press, 2005.

Champlin, John Denison. *Young Folks' Cyclopædia of Common Things*. New York: Holt, 1879.

Cobb, James. "Somebody Done Nailed Us on the Cross: Federal Farm and Welfare Policy and the Civil Rights Movement in the Mississippi Delta." *Journal of American Folk-Lore*, vol. 105, no. 415: 19; vol. 77, no. 3: 928.

Conde, Edwin G. *The Most Beautiful Land*. (Manuscript story.) ca. 1935.

Conroy, Patricia, and Sven Rossel. *The Diaries of Hans Christian Andersen*. Seattle: University of Washington Press, 1990.

Cusack, Tricia. *BBC Radio 4*. England: University of Birmingham, 2001.

Dailey, Rev. W. N. P. *The Burning of Schenectady*. Documentary Records and Historical Notes, D. D. Schenectady, NY: 1940.

Dales, Frederick. *A Story of Schenectady and the Mohawk Valley*. Schenectady, NY: Maqua, 1929.

Dawson, W. F. *Christmas: Its Origin and Associations*. London: Elliot Stock, 1902.

De Meeüs, Adrien. *History of the Belgians*. New York: Frederick Praeger, 1962.

Dissanayake, Ellen. *Homo Aestheticus: Where Art Comes From and Why.* New York: Free Press, 1992.

Dotz, Warren. *Meet Mr. Product: The Art of the Advertising Character.* San Francisco: Chronicle Books, 2003.

Fagan, Brian. *The Little Ice Age: How Climate Made History.* New York: Basic Books, 2000.

Felton, Bruce, and Mark Fowler. *Felton & Fowler's The Best, Worst and Most Unusual.* New York: Crowell, 1975.

Floore, Dr. Pieter M. *The Dutch Exploration of the North-Eastern Passage and Western Contacts with the Indigenous Population of the Arctic.* Amsterdam: ca. 1996.

Goldsworthy, Andy. *Midsummer Snowballs.* New York: Harry Abrams Publishers, 2001.

Goode, Ruth. *People of the Ice Age.* New York: Macmillan Publishing, 1973.

Greene, Nelson. *The Old Mohawk-Turnpike Book.* Fort Plain, NY: 1924.

Guthrie, R. Dale. *The Nature of Paleolithic Art.* Chicago: University of Chicago Press, 2006.

Hajdu, Peter. *The Samoyed Peoples and Languages.* The Hague, Netherlands: Indiana University Press, 1963.

Halt, Edwin Jr. *The Eskimo Storyteller.* Knoxville: University of Tennessee Press, 1975.

Hart, Larry. *Tales of Old Schenectady.* Scotia, NY: Old Dorp Books, 1875. Chap. 8, pp. 37–40.

Hemingway, Wayne. *20th Century Icons.* Bath, England: Absolute Press, 1999.

Herlihy, David. *The Black Death and the Transformation of the West.* Cambridge,

MA: Harvard University Press, 1997 (pp. 17, 41, 42).

Hone, William. *The Every-Day Book and Table Book.* Published by Assignment, 1830.

Housman, Laurence. *The Snowman: A Morality in One Act.* New York: Samuel French, 1961.

Howells, William Dean. *Novels—Selections.* New York: Viking Press, 1982.

Jackson, Frederick George. *The Great Frozen Land (Bolshaia Zemelskija Tunndra): Narrative of a Winter Journey Across the Tundras and a Sojourn Among the Samoyads.* New York: Macmillan, 1895.

Janello, Amy, and Brennon Jones. *The American Magazine.* New York: Harry Abrams, 1991.

Jones, Malcolm. *The Secret Middle Ages: Discovering the Real Medieval World.* Westport, CT: Praeger Publishers, 2002.

Joseph, Joan. *Folk Toys Around the World and How to Make Them.* New York: Parents Magazine Press, 1972.

Kael, Pauline. *Raising Kane.* New York: Bantam Books, 1971.

Kern, Louis. *An Ordered Love: Sex Roles and Sexuality in Victorian Utopias: the Shakers, the Mormons, and the Oneida Community.* Chapel Hill: University of North Carolina Press, 1981.

Kirk, Ruth. *Snow.* Seattle: University of Washington Press, 1998.

Klepper, Robert K. *Silent Films, 1877–1996: A Critical Guide to 646 Movies.* London: McFarland, 1999.

Kohn, Livia. *The Daoist Monastic Manual: An English Translation of the Fengdao kejie.* New York: Oxford University Press, 2004.

Lederer, Wolfgang. *The Kiss of the Snow Queen: Hans Christian Andersen and Man's Redemption by Woman.* Berkeley: University of California Press, 1986.

Leroi-Gourhan, André. *Treasures of Prehistoric Art.* Translated by Norbert Guterman. New York: Harry N. Abrams, 1967.

Levarie, Norma. *The Art & History of Books.* New Castle, DE: Oak Knoll Press, 1995.

Lewis-Williams, David. *The Mind in the Cave.* London: Thames & Hudson, 2002.

Little, Stephen. *Taoism and the Arts of China.* Art Institute of Chicago; University of California Press, 2000.

Livingston, Robert. *The Schenectady Massacre*, journal, 1690.

MacArthur, Greg. *Exposure: Two Plays.* Toronto: Coach House Books, 2005.

Mellinkoff, Ruth. *Outcasts: Signs of Otherness in Northern European Art of the Late Middle Ages.* Berkeley: University of California Press, 1993.

Mergen, Bernard. *Snow in America.* London: Smithsonian Institution Press, 1997.

Meyer, Robert. *Festivals U.S.A.* New York: Ives Washburn, 1950.

Meyndertsz van den Bogaert, Harmen. *A Journey into Mohawk and Oneida Country 1634–1635: The Journal of Harmen Meyndertsz van den Bogaert.* Syracuse, New York: Syracuse University Press, 1988.

Miller, Alec. *Tradition in Sculpture.* London: Studio Publications, 1949 (pp. 120, 21, 1,000).

Moffett, Charles. *Impressionists in Winter.* London: Philip Wilson Pub, 2003.

Moody, Dr. Joseph. *Arctic Doctor.* New York: Dodd, Mead & Company, 1955.

Morris, Marcia. *The Literature of Roguery in Seventeenth and Eighteenth Century Russia.* Evanston, IL: Northwestern University Press, 2000.

Morris, Richard Joseph. *Sinners, Lovers, and Heroes: An Essay on Memorializing in Three American Cultures.* Albany: State University of New York Press, 1997.

Muchembled, Robert. *Culture populaire et culture des elites dans la France moderne.* Baton Rouge, LA: Louisiana State University Press, 1985.

Mudge, Reverend Zachariah. *Arctic Heroes: Facts and Incidents of Arctic Explorations from the Earliest Voyages to the Discovery of the Fate of Sir John Franklin.* New York: Nelson & Phillips, 1875.

Muier, Count Michael. *Atlanta Fugiens.* Germany, 1617.

Neal, Avon. *Ephemeral Folk Figures: Scarecrows, Harvest Figures, and Snowmen.* New York: Clarkson N. Potter, 1969.

Nebesky-Wojkowitz, Réne von. *Where the Gods Are Mountains: Three Years Among the People of the Himalayas.* London: Weidenfeld and Nicolson, New York: Reynal, 1957.

Nellis, Milo. *History from America's Most Famous Valleys: The Mohawk Dutch and the Palatines.* St. Johnsville, 1951.

The New Encyclopedia Britannica E Report, Inc. Chicago: Encyclopedia Britannica, Inc., 1994.

Newman, Benjamin. *Hamlet and the Snowman: Reflections on Vision and Meaning in Life and Literature.* New York: American University & Peter Lang Publishing, 2000.

Newman, Paul B. *Daily Life in the Middle Ages.* London: McFarland, 2001.

Nissenbaum, Stephen. *The Battle for Christmas.* New York: Alfred A. Knopf, 1997.

Niver, Kemp R. *Early Motion Pictures: The Paper Print Collection in the Library of Congress.* Washington, DC.: Library of Congress, 1985.

Page, P. K. *The Glass Air: Selected Poems.* Toronto: Oxford University Press, 1985.

Parson, Professor Jonathan A. M. *A History of the Schenectady Patent.* Albany: Joel Munsells Sons, Printers, 1883.

Perez-Higuera, Teresa. *Medieval Calendars.* London: Trafalgar Square, 1999.

Perkins, Bill. *The Naked Truth: Sexual Purity for Guys in the Real World.* Grand Rapids, MI: Zondervan/Youth Specialties, 2004.

Perrie, Maureen. *The Pretenders and Popular Monarchism in Early Modern Russia.* Cambridge: Cambridge University Press, 1995.

Pleij, Herman. *De sneeuwpoppen van 1511: Literatuur en Stadscultuur Tussen Middeleeuwen en Moderne Tijd.* Amsterdam: Meulenhoff, 1988.

———. *Dreaming of Cockaigne: Medieval Fantasies of the Perfect Life.* New York: Columbia University Press, 1997.

———. *Flanders in a European Perspective: Manuscript Illumination Around 1400 in Flanders.* New York: Columbia University Press, 1995.

Plummer, Mark A. *Lincoln's Rail-Splitter.* Urbana: University of Illinois Press, 2001.

Quennell, Marjorie and C. H. B. *Everyday Life in Prehistoric Times.* New York: G. P. Putnam's Sons, 1980.

———. *A History of Everyday Things in England from 1066–1799.* London: G. P. Putnam's Sons, 1931.

Ravitch, Diane. *The Language Police: How Pressure Groups Restrict What Students Learn.* New York: Alfred A. Knopf, 2003.

Rcid, W. Max. *The Mohawk Valley: Its Legends and Its History.* New York: Knickerbocker Press, 1901.

Ristinen, Elaine, trans. *The Nganasan: The Material Culture of the Tavgi Samoyeds.* Bloomington: Indiana University Press & The Hague: Mouton & Co., 1966.

Robb, Graham. *Strangers: Homosexual Love in the 19th Century.* London: Picador, 2003.

Roberts, George S. *Old Schenectady.* Schenectady: Robson & Adee Publisher, 1904.

Roberts, Mary Newlin. "Michelangelo and The Snowman: Episodes from the Life of a Young Michelangelo." *Child Life*, Benjamin Franklin Literary & Medical Society, April 2000.

Robiano, Eugen-Jean-Bapiste. *Collection des desseins des figures Colossales & des Groupes qui ont ete faits de Neige.* Aanvers, France, 1772.

Rogers, Robert. *Amazing Reader in the Labyrinth of Literature.* Chapel Hill: Duke University Press, 1982.

Rose, Barbara. "Jasper Johns: The Seasons." *Vogue*, January 1987.

Rosenblum, Naomi. *A History of Women Photography.* New York: Abbeville Press, 1994.

Rosenkranz, Patrick. *Rebel Visions: The Underground Comix Revolution, 1963–1975.* Seattle: Fantagraphics Books, 2002.

Roth, Norman. *Medieval Jewish Civilization: An Encyclopedia.* New York: Routledge, 2003.

Sanders, John. *Early History of Schenectady and Its First Settlers.* Albany, NY: Van Benthuysen Printing House, 1879.

Sands, George. *The Snow Man.* Boston: Roberts Brothers, 1871.

Shakespeare, William. *The History Plays.* New York: Henry Holt and Company, 1951.

Spivey, Nigel. *How Art Made the World: A Journey to the Origins of Human Creativity.* New York: Basic Books, 2005.

Stevens, Wallace. *The Collected Poems of Wallace Stevens.* New York: Alfred A. Knopf, 1954.

Suchtelen, Ariane van. *Holland Frozen in Time: The Dutch Winter Landscape in the Golden Age.* Zwolle, Netherlands: Waanders Publishers, 2001.

Sylvester, Nathaniel Bartlett. *History of Saratoga County.* Philadelphia: Everts & Ensign, 1878.

Thomas, Dylan. "Foster the Light." *The Columbia World of Quotations.* Columbia Encyclopedia, 1996.

Uglow, J. *Nature's Engraver: A Life of Thomas Bewick.* London: Faber, 2006 (pp. 127–8).

Vasari, Giorgio. *The Lives of the Most Excellent Painters, Sculptors and Architects.* 1550.

Veeder, Millicent. *Door to the Mohawk Valley: A History of Schenectady for Young People.* Albany: Cromwell Printery, 1947.

Veer, Gerritt de. *Diarivm navticvm.* Amsterdam, 1598.

Vrooman, John J. *The Massacre.* Johnstown, NY: The Baronet Litho Company, 1954.

Wagner, Linda. *Critical Essays on Sylvia Plath.* Boston: G. K. Hall & Company, 1984.

Welles, Orson, and Herman J. Mankiewicz. *The Shooting Script.* Boston: The

Atlantic Monthly Press, 1941.

Whitburn, Joel. *Pop Memories, 1890–1954: History of American Popular Music.* Menomonee Falls, WI: Billboard Publishing, 1986.

White, Curtis. "The Spirit of Disobedience: An Invitation to Resistance." *Harper's,* April 2006.

White, Randall. *Prehistoric Art: The Symbolic Journey of Humankind.* New York: Harry N. Abrams, 2003.

Whittaker, C. E. *Arctic Eskimo.* London: Secley, Service, 1937.

Willoughby, Martin. *A History of Postcards.* London: Bracken Books, 1992.

Wullschläger, Jackie. *Hans Christian Andersen: The Life of a Storyteller.* London: Allen Lane, 2000.

Zeni, David. *A Forgotten Empress.* Fredicton, New Brunswick: Goose Lane, 1998.

ACKNOWLEDGMENTS

I am indebted to many who provided research for this book. I'd like to thank my assistant/translator Sander M. van Zijl; art theorist Matt Gatton; Professor S. Hollis Clayson, Northwestern University; Dr. Nigel Spivey, University of Cambridge; Professor Dale Guthrie, University of Alaska; Christopher Grotke, cofounder of iBrattleboro.com; Daniel Boucher, Cornell University; Laura Linder and Ellen McHale, New York Folklore; Sarah Johnson, PhD, Jacques Marchais Museum of Tibetan Art; Professor T. H. Barrett, University of London; Iwan Jones, National Library of Wales; Jerry Carbone, Brooks Memorial Library; Dr. Malcolm Jones, University of Sheffield, England; Dr. Keith "The Weather Doctor" Heidorn; Jack Larkin, Old Sturbridge Village; Barbara Binder, National Museum of Photography, Film and Television, England; Keith Moxey, Columbia University; B. Caroline Sisneros, Louis B. Mayer Library; Dr. Norbert Fischer, Institute of City History, Frankfurt; Walter A. Van Horn, Daniel Odess, and Molly Lee, PhD, University of Alaska Museum; William Schneider and Rose Speranza, University of Alaska; Dr. K. A. H. W. Leenders, The Hague, Netherlands; Becky Cape, The Lilly Library, Indiana University; John Bidwell and Inge Dupont, Pierpont Morgan Library; Bonnie Wilson, Minnesota Historical Society; Elín Guojonsdottir, National Gallery of Iceland; Virginia

Lagoy, Grems Doolittle Library; Jennifer Miller, UCLA Film & Television Archive; and Eric Robinson, New York Historical Society Library.

Without the help and wisdom of Professor Herman Pleij of the University of Amsterdam, the leading authority on Dutch historical literature and snowman making in the Middle Ages, this book would not be complete. I would like to thank him for the patience and kindness he extended to me.

I would like to thank my friends at the New York Public Library who worked on my book: David Smith, Thomas Lisanti, Wayne J. Furman, Margaret Glover, John F. Rathe, Stewart Bodner, Rob Scott, Jay Vissers, and Qi Xie.

I was very fortunate to have many famous artists help me. It was an honor to include in my book: Paul Coker, Jr. (creator of Frosty and *Mad* magazine genius); Sam Gross (world's greatest cartoonist); and John Callahan, Robert Crumb, Matt Martin, and Leigh Rubin. Thank you to Keith Miserocchi of the Charles Addams estate.

Three well-known fine artists generously contributed their genius to this book: Gary Hume, Dennis Oppenheim, and David Humprey. Thanks to artists Mel B. Gerstein, president of Frost King, and Ray (yessy.com/artgallery).

The logistics of getting all the art for this book could not have happened without the cooperation of the following. I'd like to thank Rick Goldschmidt (Rankin/Bass historian, enchantedworldoffrankinbass.blogspot.com); Jennifer Weidman (Simon Spotlight Entertainment), William Christensen (Avatar Press), Sion Jobbins (The National Library of Wales), Jennifer Belt (Art Resource), Pam Woodruff and John P. Kelly (AMAFCA), Robin Zinchuk (Bethel Area Chamber of Commerce), Heather Penn (United Media), Pia Hiefner-Hug (Orell Fuessli), Marilyn Small (Scholastic), Marianne Sugawara (Creators Syndicate), Jamie Kitman, They Might Be Giants, Justin Hobson (Royal Geographical Society), Christina Turley (Matthew Marks Gallery), Sara Macdonald and Sophie Greig (White Cube, London), Lora Fountain, Merrideth Miller (The Cartoonbank), Dr. Melanie Wood and Frank Addison (Robinson Library, Newcastle University), Barbara Brow (Wikipedia), AnnaLee Pauls, Mary George and Charles Greene

(Princeton University), Dudo Erny (bigfoto.com), Bette Graber (Random House), Anne Klar, Luc Lenvain, Max Guernsey, Dmitry Levit, and Linda Kalteux.

Special thanks to my family and friends for their support and for letting me know when the book needed more cowbell. A select few who provided indispensable contributions include: Len Belzer, Marcy Dermansky, Joseph Eckstein, Mark Kalinoski, John Kacht, John Marchese, Dolores Motichka, Kurt Oppreicht, Adam Penenberg, Rob and Nani Rombout, Melissa Scheld, Tina Simms, Mike Stevens, Jill Weiner, Catherine Widmark, and Ben Wolf. Special thanks to Susan Stauber, whose judgment kept the ship right.

I am very grateful to my friend Adam for introducing me to the best agent there is, Joy Tutela. Joy is always in my corner fighting to keep our original vision and my sanity. I am grateful for our friendship. Special thanks to her and her assistant, Johnathan Wilber, for all their hard work on this book. I'd like to thank Ryan Harbage, who believed in the book and continued to provide me guidance after he left SSE, and Terra Chalberg for all her contributions and editorial direction. To my last editor, Ursula Cary, I am very grateful and hope in the future we will work on many fun projects together. Thanks also to everyone at Simon Spotlight Entertainment, especially Jane Archer, who did a beautiful job designing this book.

To my wife, Tamar Stone, who often put aside her own art to work on my project, I cannot thank her enough. She helped on all aspects of the book and was in charge of encouragement. She told me I should write this book and I trusted her.